HIDDEN
HISTORY
of
PITTSBURGH

HIDDEN
HISTORY
of
PITTSBURGH

Len Barcousky

THE
History
PRESS

Published by The History Press
Charleston, SC
www.historypress.net

First published 2016

ISBN 978-1-5402-0351-9

Library of Congress Control Number: 2016932977

In memory of my mother, Nora Muskelavage Barcousky.

CONTENTS

Preface

PULLING BACK THE CURTAIN
ON HISTORY

N̲ews from the dedication of the new national cemetery at Gettysburg was surprisingly late reaching Pittsburgh in 1863. "This famous little town is overflowing with people," the *Daily Pittsburgh Gazette* reported on November 20, 1863, in a skimpy two-sentence story the day after the ceremonies. "Special trains have brought thousands, and other thousands have come in from the surrounding country."

Why so brief a dispatch when the *Gazette* had sent its own reporter to the event? After all, by 1863 telegraph operators could send breaking news across the nation in a matter of minutes after events occurred. The cemetery dedication had ended by 2:30 p.m. on November 19. That should have offered plenty of time to get a story in the next morning's editions.

The *Gazette*'s on-the-scene correspondent, identified only by the initial "H," offered an explanation the next day. "It is difficult for a Western reporter to get justice at the East," he wrote in the *Gazette* on November 21. Reporters from the big eastern papers "have the [telegraph] operators under their heels, and I have reason to believe that 10,000 words were crowded in ahead of my dispatch last night, driving me off at a late hour to a distant point to get anything off before two o'clock a.m.," he complained. "H" had to hop aboard a train and send his report from Conemaugh, outside Johnstown, Pennsylvania. By the time he got there, it was much too late for his copy to make the morning newspaper.

I can identify. For more than forty years I have struggled with damaged payphones, sometimes surly news clerks, balky fax machines, slow photo

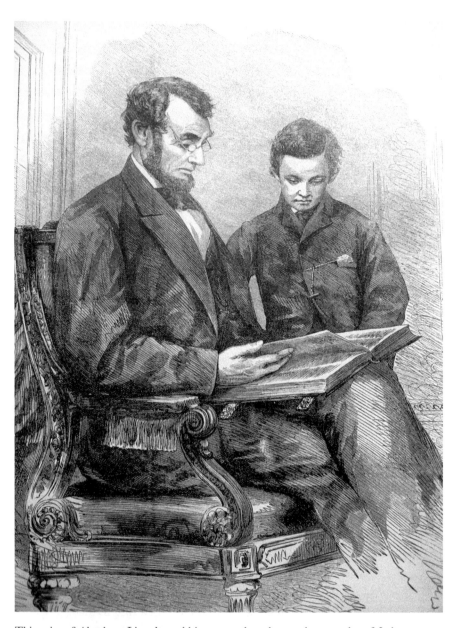

This print of Abraham Lincoln and his son was based on a photo made at Mathew Brady's studio in February 1864. A popular portrait of the president, it shows him wearing glasses. From *Harper's Pictorial History of the Civil War, Part Second. Courtesy Senator John Heinz History Center.*

transmitters, cranky laptop computers, bad phone connections and spotty Internet service in efforts to file remotely on deadline. Maybe that is the reason I have enjoyed writing so many stories about Pittsburgh's past. Most of them have been researched in the quiet of the Carnegie Library of Pittsburgh. While I still faced deadlines in completing those brief looks into the region's past, my reports most often were sent with the touch of a button from one in-office computer to another.

The primary source for these "hidden" gems has been the *Pittsburgh Post-Gazette* archives. Dating back to 1786, these old newspapers reflect 230 years of both daily living and historic changes in southwestern Pennsylvania. Those reports have brought me closer to my ink-stained predecessors—almost always anonymous—as they and I have struggled to make sense of the region and the world.

Much of what I have found has held up well. The *Pittsburgh Gazette* and its successor publications have been on the right side of history in support of causes that have included abolition, national union and civil rights. Stories about religion, science and the arts have had pride of place. Whenever a famous musician, writer or politician came to town over the past two centuries, reporters from the *Post-Gazette* and other local newspapers were there to interview and review. At times of national tragedy, such as the sinking of the *Lusitania* in 1915, *Post-Gazette* writers have found local angles to bring the story home to readers.

Their reports have not so much dealt with hidden history, but rather history that always is at risk of being forgotten. And that would be too bad. Most news stories, especially in the age of the Internet, have the lifespan of a mayfly. Almost all of the nineteenth- and twentieth-century stories on which this book is based were reported, written and printed in a day. These "Hidden History" tales, nevertheless, deserve another look. They show how ordinary and extraordinary people have responded to challenge. They include new anecdotes that reveal the character of historic figures. They show us what life was like here during war and peace.

I have long been telling a silly story about a newsboy peddling papers years ago at the corner of Grant Street and Liberty Avenue in downtown Pittsburgh. He was yelling, "Read all about it. Fifty people swindled! Fifty people swindled!"

Curious, a man walked over and bought a paper. He checked the front page and then looked through the rest of the paper. Finding nothing about a swindle, the man walked over to the newsboy and complained, "There's nothing in here about fifty people being swindled." The newsboy

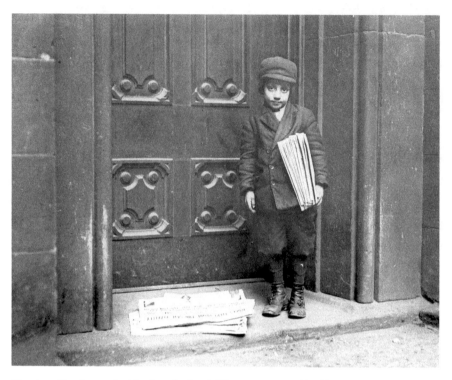

Newsboys like the one in this photo by Lewis Hine were accused by Pittsburgh's police commissioner in 1915 of making up headlines to sell more papers. *Courtesy Library of Congress.*

ignored him and started calling out, "Read all about it. Fifty-one people swindled!"

I thought I was making a joke, but it turns out the story was more true than I knew. Looking through microfilm from the *Pittsburgh Gazette Times* published in 1915, I found a story about a minor scandal roiling Pittsburgh: "Newsboys and Young Men Masquerading as Newsboys Will Have to Stop 'Faking' in Order to Sell Their Papers," the newspaper reported on January 3, 1915. Police Superintendent W. Noble Matthews issued the warning in response to reports that "cases of newsboys crying up their wares with false statements are increasing." Serious crime in Pittsburgh really must have slowed down that winter.

"The superintendent yesterday ordered the police to investigate the exaggerated and false claims of the 'newsies,' evidently designed to mislead the public into buying papers," the story said. "Supt. Matthews said he believed many of the exaggerations were made by other than regular

newsboys who went into residential districts to sell their papers," the *Gazette Times* reported. "He said the news contained in the papers sold by the boys must justify the selling points which they cry or the police are authorized to take them in hand."

Matthews claimed some success in his honesty-in-news campaign. "The superintendent had a few of the offenders 'on the carpet' recently, and these promised to reform their methods," the story concluded.

Once again, I've found reality that beats fiction. You can't make this stuff up, and you certainly shouldn't keep it hidden.

ACKNOWLEDGEMENTS

It was 2002 when I first wrote in the *Pittsburgh Post-Gazette* about George Washington's multiple adventures in southwestern Pennsylvania. During the fourteen years that followed, I have been given time and resources to write several hundred stories about the region's past. I remain grateful for the support of this effort by the top editors of this newspaper, especially publisher and editor-in-chief John Robinson Block and executive editor David M. Shribman. My immediate supervisors—including Tom Birdsong, Lillian Thomas, Ken Fisher and Virginia Kopas Joe—have allowed me to juggle my other writing duties and spend time rooting around in the newspaper's archives. Special thanks to Gary Rotstein, the longtime editor of the *Post-Gazette*'s Page 2 features, where versions of many of these "Eyewitness" reports first appeared.

I remain in debt to the newspaper's copy desk, headed by David Garth. My colleagues regularly saved me from myself through their questions, challenges and suggestions for improvement. *Post-Gazette* photography is also an important part of this book. Thanks to the *P-G*'s Andy Starnes and Jim Mendenhall for their cooperation in assembling photos and engravings. Allison Latcheran, the newspaper's marketing services manager, once again has supported this book project (my third). The staff at The History Press, especially commissioning editor Karmen Cook and production editor Ryan Finn, have been unfailingly helpful.

Writing Pittsburgh history requires the aid of local libraries and their skilled librarians. They include Angelika Kane and Steve Karlinchak at

the *Post-Gazette* and chief librarian Art Louderback and chief archivist Matthew Strauss at the Senator John Heinz History Center. Reference staff members in the Pennsylvania Room of the Carnegie Library of Pittsburgh, especially Marilyn Holt and Gilbert Pietrzak, have been helpful, pleasant and patient on my many visits to that institution. My wife, Barbara, once again has listened to me talk through the project. She then pitched in on the final editing.

Chapter 1

FINDING THE LOCAL ANGLE

1863: MR. LINCOLN OFFERS A CORRECTION

The *Daily Pittsburgh Gazette* had sent its own reporter to Gettysburg for the dedication of the new national cemetery there. The newspaper story that appeared on November 21, 1863, presented a version of the event that was highly complimentary to President Abraham Lincoln. The dispatch also includes an anecdote about the president's attention to detail.

Lincoln made his brief remarks following what the *Gazette* reported was a two-hour, four-minute oration by sixty-nine-year-old Edward Everett. Everett had served as U.S. secretary of state, governor of and senator from Massachusetts and president of Harvard. He had a national reputation as a speaker in an era when people came long distances to hear political speeches. They expected and appreciated lengthy addresses.

Everett delivered. He quoted poetry and drew parallels to events in Ancient Greece as he reviewed the three-day battle at Gettysburg. As he spoke, "the most attentive and appreciating listener was old Abe himself," wrote the *Gazette* correspondent, identified only as "H": "He seemed to be absorbed in profound thought till the spell was broken, by a mistake of the orator, in saying [Confederate commander] Gen. Lee, when he should have said [Union commander] Gen. Meade." When Lincoln caught the error, he turned to William Seward, his secretary of state, and "with a loud voice" said, "'Gen. Meade,' but the speaker seemed not to hear it at this time."

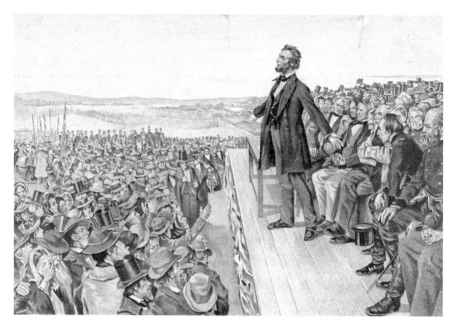

The crowd assembled for President Abraham Lincoln's Gettysburg Address on November 19, 1863, included a reporter from the *Gazette*. *Sherwood Lithograph Company print, courtesy the Library of Congress.*

When Everett "again made the same mistake," Lincoln corrected him in a louder tone. This time, the president's comment was enough "to secure a correction by the orator."

The *Gazette*'s correspondent estimated the size of the crowd at between thirty thousand and fifty thousand people, and at least some appeared to have been restive and noisy during the start of Everett's address. "For some minutes after the orator commenced, there was considerable confusion to the right that seemed not easily to be silenced," the story said. "The crowd was packed so densely that the marshals who sat on their horses amidst the multitudes could not move toward the desired quarter."

"But at length, [during] an impressive passage of the orator, contrasting the importance of the Grecian struggle at Marchion with that of our Republic on the spot where he stood, the dense crowd gave way and a breathless attention was maintained throughout." The reference to "Marchion" probably is the reporter's mishearing of a reference to the Greek victory over the Persians in 490 BC at Marathon. "At the conclusion of the oration, a choir from the Musical Association of Baltimore treated the people to a beautiful dirge, written at Gettysburg," the story said.

Then it was Lincoln's turn. "[The] President unwound himself, stepped to the front of the platform and recited in a high and singing voice, his hymn to the Union dead," biographer Stephen B. Oates wrote in his life of Lincoln, *With Malice Toward None*.

One common narrative regarding Lincoln's Gettysburg Address is that the crowd at the cemetery had been disappointed both by the short length and the content of the president's speech. "Lamon, that speech won't scour," the president is supposed to have said to his friend Ward Hill Lamon. Historian David Herbert Donald wrote that Lincoln's reference was to an inefficient plow that allowed soil to build up on its blade. "No doubt his judgment was also affected by his fatigue and by illness, which would prostrate him by the time he returned to the White House," Donald wrote in his 1995 biography.

The *Gazette*'s man on the scene didn't see it that way. The *Gazette* was the city's major Republican newspaper, and it had been supporting the president since his run for the office in 1860. Lincoln's introduction was greeted by "immense applause," the story said.

"Four score and seven years ago our fathers established, upon this continent, a government subscribed in liberty and dedicated to the fundamental principles that all men are created equal." Lincoln wrote and rewrote his speech multiple times and made additional corrections after he delivered it. His opening sentence as reported in the *Gazette* story differs from the standard version printed in history books, but it was, nevertheless, met by shouts of "Good, good" and additional clapping and cheering. The *Gazette* story notes that the president's brief speech was interrupted multiple times by "Great applause," "Immense applause" and more cries of "Good."

"Here let us resolve that what they have done shall not have been done in vain," Lincoln says in the *Gazette* story. "That the nation shall, under God, have a new birth of freedom, and that Government of the people, founded by the people, shall not perish." Modern readers will miss the closing phrase "for the people," but the crowd didn't mind. "The conclusion of the President's remarks was followed by immense applause, and three cheers given for him," the story said.

"A powerful impression was made this day upon the nation," the *Gazette* story concluded. "More than any other single event will this glorious dedication serve the heroism and deepen the resolution of the living to conquer all hazards," he wrote. "More than anything else will this day's work contribute to the nationality of the great republic."

1894: SLOW START FOR LABOR DAY

When William Green spoke to union members and supporters at West View Park, northwest of Pittsburgh, on Labor Day 1932, he made some of the same points that his successors have been raising each September ever since. Green, the president of the American Federation of Labor, called for shorter working hours, the restoration of previously reduced wages and "a more equitable distribution of wealth." The AFL merged in 1955 with the Congress of Industrial Organizations to form the nation's largest federation of unions, the AFL-CIO.

The Great Depression was in its third year when Green spoke. Almost one in four Americans was unemployed. The gross national product had declined by one-third when compared to 1929, and ten thousand banks had failed. In response to the flood of bad news, organized labor sponsored the first Labor Day parade in Pittsburgh in more than a dozen years, according to the September 6, 1932 edition of the *Pittsburgh Post-Gazette*.

The 1932 march continued a tradition in southwestern Pennsylvania that extended back to 1894. That's when Congress established a day to honor workers. In the years since Labor Day was made a national holiday, it has been marked in Pittsburgh and southwestern Pennsylvania by a mix of parades, picnics, speeches, monument unveilings, fairs and religious services.

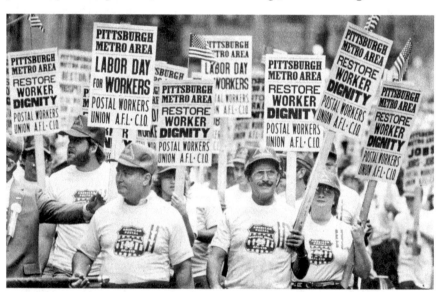

Postal workers march along Fifth Avenue during Pittsburgh's Labor Day parade in 1984. *Courtesy the* Pittsburgh Post-Gazette.

The holiday got off to a slow start here. "All the banks and government offices were open all day yesterday as usual," the *Pittsburgh Commercial Gazette* reported on September 4, 1894. That was because the state legislature had chosen the first Saturday in September rather than the first Monday of the month to honor workers. "It is hoped that the next session of Pennsylvania's legislature will change its enactment so as to bring it into conformity with the rest of the country," the newspaper said. Some labor groups were not waiting. "The building trades will celebrate Labor Day at Ross grove today by holding a picnic [in nearby O'Hara Township]," a *Gazette* story reported on that first national holiday.

Things hadn't changed by the next year, and Saturday remained the official state holiday. "Pittsburgh with some of the ante-bellum spirit of state sovereignty borrowed from her southern neighbors bows in loyalty to Harrisburg," the *Gazette* reported on September 3, 1895.

As its name suggested, the *Pittsburgh Commercial Gazette* was the city's business newspaper, and its pages that year included a tongue-in-cheek tribute to the workers' holiday. "It was Labor day yesterday, and all through the United States large numbers of workingmen triumphed over capitalism by taking a holiday at their own expense," the newspaper said.

That situation had changed dramatically by 1914. That year, the Pittsburgh Labor Day parade attracted thirty-five thousand union members, according to two reports in the October 1914 edition of the *American Flint*. The monthly magazine was published by the Flint Glass Workers Union of America. The 1914 parade marked "the first time in over twenty years that the glass workers marched in a Labor Day parade in Pittsburgh," the story said, quoting the *Pittsburgh Leader*. "Glass canes the men had made, from which fluttered tiny red, white and blue pennants, furnished one of the unique features of the glass workers' procession," the newspaper added.

The mood on Labor Day 1932 was somber. Green, the national union leader, warned that high levels of unemployment would "bring suffering never known before by American workers," the *Post-Gazette* reported on September 6. That hardship would occur even though "economic skies were clearing and that faith and confidence are being restored," the AFL head said.

Unemployment rates hadn't changed the next year, but the mood was brighter with multiple Labor Day events taking place around the region. President Franklin Delano Roosevelt had been inaugurated in March 1933, and in the next one hundred days Congress passed legislation to tackle the Great Depression. Gathering once again at West View Park, union members

heard multiple speakers pledge to defend workers' gains under the National Recovery Administration's "Blue Eagle" program.

"McKeesport was the scene of a huge miners' and steel workers' parade, with more than 5,000 persons in the line of march," the *Post-Gazette* reported on September 5, 1933. Former governor Gifford Pinchot was the main speaker at a labor rally in Uniontown, while Reverend James R. Cox and Charlotte Carr, the state secretary of labor and industry, addressed a rally in Washington, Pennsylvania. "Meanwhile, other thousands of Pittsburghers enjoyed Labor Day outings to parks and picnics grounds," the newspaper reported. "Crowds viewed the Allegheny County Fair on its closing day [in South Park] and many watched the boat races at Oakmont and other sports events."

World War II had begun in Europe in 1939. While the United States was not yet at war, the Labor Day commemorations on September 1, 1941, emphasized preparedness. The keynote message of the holiday was "the workers' part in the defense of the country," the *Post-Gazette* reported on September 2. "An estimated 25,000 Carnegie-Illinois workers at Homestead and other plants, and additional thousands of employees of Jones and Laughlin and other steel concerns, maintained their 24-hour [work] schedule," the story said. There were parades through Homestead and Munhall "while a flight of army planes roared overhead." Another thirty thousand union workers marched through Pittsburgh. It was also a year for remembering labor's past. The Steel Workers Organizing Committee (SWOC), a predecessor to the United Steelworkers, unveiled a marble monument in Homestead to the men killed during the Homestead Strike of 1892.

World War II had ended by Labor Day 1945, and the *Post-Gazette* reported that the holiday was marked "in old style," with picnics, travel and swim parties. "In contrast to the hum of industry that was maintained even on holidays during the war period, district industrial plants joined with public offices and business houses in closing for the day," the newspaper said on September 4.

One of the highlights of the celebration on September 1, 1952, was a whistle-stop appearance by President Harry Truman. The president gave about three thousand Democrats gathered at Pennsylvania Station a get-out-the-vote pep talk before the presidential election. He predicted that Adlai Stevenson would carry Pennsylvania in his race against Dwight Eisenhower. The president delivered what the newspaper described as about five minutes of off-the-cuff remarks from the back of his train. Truman guessed wrong. Eisenhower carried Pennsylvania and won the election.

The year 1959 saw the start of a new tradition: an annual Labor Day Mass. The first service was celebrated in St. Paul Cathedral in Pittsburgh's Oakland neighborhood, but the location has varied over the decades. Labor Day Masses in honor of St. Joseph the Worker have been held in the now demolished Civic Arena, the former St. Mary Magdalene Church in Homestead and St. Benedict the Moor Church in Pittsburgh's Hill District. Clergy from other faiths have taken part in some of the services.

Labor Day parades were interrupted in the late 1960s, but the event was revived with enthusiasm in 1984. "Sponsors of Pittsburgh's first Labor Day parade in 16 years yesterday described it as a big success," the *Post-Gazette* reported on September 4. About fifteen thousand spectators watched workers and their families representing more than one hundred union locals as they marched through the Golden Triangle, the newspaper story said.

The annual parades have continued without interruption every year since then, with Pittsburgh reported to have the nation's second-largest Labor Day celebration. Each year's march draws as many as seventy thousand participants—union workers, labor supporters and local politicians. "It's always a great day for union members and their families," according to Jack Shea, president of the Allegheny County Labor Council. The council is a federation of more than 170 union locals. "We're proud of the work we do and we are proud of our unions," he said in a 2015 interview. "We'll march even if it is snowing."

1915: How the *Lusitania* Horror Hit Home

After a German U-boat sank the *Lusitania* on May 7, 1915, much of the initial newspaper attention focused on the fates of millionaire Alfred Gwynne Vanderbilt and Broadway producer Charles Frohman.

The story came much closer to home for Pittsburgh readers as the *Gazette Times* and the *Pittsburg Press* sifted through conflicting reports on what had happened to more than a dozen southwestern Pennsylvanians reported to be aboard the doomed ocean liner. (Between 1891 and 1911, the federal government had decreed that Pittsburgh be spelled without the final *h*. The *Press* complied, while the *Gazette* retained the original spelling.)

An optimistic United Press news service bulletin appeared in the late edition of the *Press*, an afternoon newspaper, on May 7. It claimed that "all the Lusitania's passengers were saved." That report soon proved untrue.

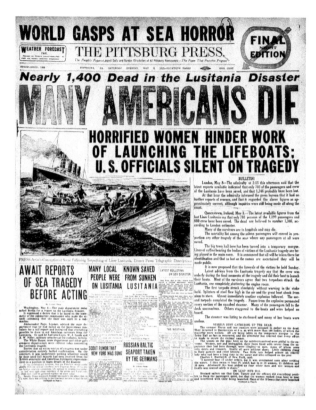

The May 8, 1915 edition of the *Pittsburg Press* had a front-page story and art dealing with the British ship's sinking. *Courtesy the Pittsburgh Post-Gazette.*

The May 8 edition of the *Gazette Times* reported 1,409 people dead and just 658 survivors. In the days that followed, the number of survivors rose and number of fatalities fell, but the scope of the disaster remained immense. Of the British ship's 1,959 passengers and crew members, only 761 people survived. Those casualties included 128 Americans, but the fate of many people with Pittsburgh connections remained heartbreakingly unclear for several days.

When the *Lusitania* was sunk, World War I had been underway in Europe for nine months. The United States had remained neutral in the conflict. Britain's powerful navy had cut off most German shipping—including food—with a blockade. Kaiser Wilhelm's government had responded with submarine warfare, sinking British merchant ships and threatening passenger liners suspected of carrying military supplies.

The Imperial German Embassy in Washington had issued a warning to passengers traveling on British ships just before the *Lusitania* sailed on May 1 from New York. The statement gave "formal notice" that "vessels flying the flag of Great Britain, or any of her allies, are liable to destruction" when

passing through war zones. Those war zones included "the waters adjacent to the British Isles."

That warning was enough to persuade North Side resident Robert Spiers to reconsider his decision to sail on the British-flagged ship, according to a story in the May 8 edition of the *Gazette Times*. He was unable, however, to persuade his niece, Margaret Anderson, to change her plans. Mrs. Anderson, who lived on Liverpool Street in Pittsburgh's Manchester neighborhood, had boarded the *Lusitania* to visit her family in Belfast, Ireland. She and her traveling companion, Margaret Kelly, another North Side resident who worked as a stenographer, had adjoining second-class staterooms, according to the *Gazette Times*. "Last night Mr. Spiers said that he had been unable to sleep since the departure of his niece as he had a deep-rooted premonition that misfortune would befall the steamer," the newspaper story said. The *Lusitania* was within a dozen miles of the coast of British-ruled Ireland when a German submarine fired a torpedo shortly after 2:00 p.m. local time. The ship sank in just eighteen minutes.

An undersea cable had linked Britain and the United States for decades, and both news stories and messages about survivors and victims were transmitted quickly across the ocean. The sinking of the *Lusitania* reminded many of the loss of the *Titanic* after it struck an iceberg in 1912. "The memory of the terrible scenes on board the Titanic brought terror to scores of Pittsburghers when they learned that their friends and relatives might be among the hundreds reported drowned," the *Gazette Times* said.

By Sunday, May 9, the deaths of Vanderbilt and producer Charles Frohman had been confirmed. The status of hundreds of other passengers, including many from Pittsburgh, remained unknown. "Residents of nearby towns known to have been rescued are Mrs. James Tierney and her daughter, Nina, of Vandergrift," the *Gazette Times* reported. "Those yet to be reported either safe or lost" included Mrs. Anderson, Miss Kelly and a third North Sider, Miss Winifred Kilawee. (Her last name was also spelled Killawee in some stories.)

"Yesterday witnessed a continual stream of visitors at the local steamship offices," the story said. "Some of the scenes around the agencies were pathetic. George A. Anderson of the Crucible Steel Co., whose wife was a passenger on the vessel, was in the office every few minutes hoping to hear news of his wife. He had not slept for 48 hours. All his telegrams to New York had failed to bring real information regarding her fate.... Shortly after noon, James Tierney came into the office and with a sigh of relief told the

attaches that after walking the streets all night he had learned his wife and daughter had been rescued."

The early reports of those saved also included North Siders Mr. and Mrs. Thomas Brownlee, several people from Wilkinsburg and a mother traveling with her two young sons from Ellwood City. Mrs. Herbert Owens was reported safe, but her two sons, Ronald, eleven, and Reginald, eight, were still missing. "It is feared also that the two sons of Mrs. Owens perished, her name alone appearing in the list of rescued."

Miss Kilawee, whose fate remained unknown, was a forty-six-year-old immigrant from Ireland's County Sligo. She had worked as a house servant in Sewickley and later as a waitress at a downtown restaurant. She was traveling on the *Lusitania* to see her invalid mother back in Ireland, the newspaper reported.

The May 10 edition of the *Gazette Times* brought renewed hope about the fate of Miss Kilawee. "The mention in the latest list of additions to the list of survivors may lead to the discovery that Miss Winifred Killawee of Pittsburgh has been saved," the story said. Her name had been transmitted as "W. Kennaway," according to the paper.

Herbert Owens in Ellwood City also got some good news that day. His wife cabled from Queenstown, Ireland, that she was sailing back to America immediately. Queenstown is now Cobh. "While Ronald and Reginald have not been officially reported saved, Mr. Owens believed they must have been rescued or Mrs. Owens would not start for home so soon," the story said.

George Anderson remained in suspense. He got a cablegram from his father-in-law saying only, "No information. Will wire if saved." The next day's newspaper, however, reported better news. A follow-up telegram from his father-in-law read, "Margaret safe." Mr. Anderson and his wife had been married for about a year. He had been preparing to cancel contracts for construction of their new home when he got word of his wife's survival. "The little house will be built after all," the *Gazette Times* said on May 11. Sadly, a third telegram followed: "Awful mistake, dear Maggie lost. Deepest sympathy," her father wrote his son-in-law the next day.

The May 13 edition of the *Gazette Times* contained more bad news. In addition to Mrs. Anderson, Mrs. James Tierney and her daughter, Nina, who originally had been reported to have been saved, had perished. The death of Miss Kelly, the North Side stenographer, also was confirmed. Thomas Brownlee, initially reported rescued, had not survived the sinking. "The latest bulletins state that only Mrs. Brownlee was rescued."

That day's paper did contain a piece of good news. "Wilfred Kanaway" was believed to actually be Pittsburgh's Miss Winifred Killawee. "Her friends are now certain that Miss Killawee is the person mentioned in the telegram," the *Gazette Times* reported on May 13. That information was confirmed in the next day's paper. "It is now definitely known that Miss Winifred Kilawee… was saved and is now in a Queenstown hospital," the *Pittsburg Press* reported on May 14. "Her injuries are not considered serious."

While the sinking of the *Lusitania* and the deaths of so many U.S. citizens turned much of American public opinion against Kaiser Wilhelm's Germany, President Woodrow Wilson resisted calls for a declaration of war. His position was helped by a German apology and a modification of the policy of unrestricted submarine warfare. Eighteen months later, in November 1916, President Wilson won reelection to a second term, campaigning with the slogan, "He kept us out of war." Shortly after Wilson's election victory, Germany reinstated its policy of unrestricted submarine warfare. On April 2, 1917, Wilson asked Congress to declare war on Germany, and the United States entered World War I.

1936: St. Patrick's Day Flood Up Close

This natural disaster became known as the Great St. Patrick's Day Flood, and it also hit other areas of the Mid-Atlantic on both sides of the Eastern Continental Divide.

Mabel Sage remembered watching garages and other small buildings floating by under the West End Bridge on a March morning in 1936. Viola Stanny recalled that police stopped her near Smithfield Street and Fifth Avenue. Streets in Pittsburgh's Golden Triangle were filling with water. Officers told her that she would have no classes that day at Pittsburgh Academy, the business school she attended on Wood Street.

Both women had seen high water in Pittsburgh before. Neither realized that she was a getting firsthand look at the worst flood in the city's history. Pittsburgh was not alone in getting hammered by the combination of rapidly melting snow and heavy rains. Towns were washed out from New England to Maryland. Locally, the melting snow and rain combined to send the Monongahela and Allegheny Rivers high above their banks on March 17 and 18, 1936. The resulting flood submerged downtown streets and the lower floors of buildings in an area that stretched from Pittsburgh's Point to

near Grant Street. The raging rivers killed more than 150 people throughout the tri-state Ohio Valley, including 45 in the city.

In an era without instant communications, most people were not immediately aware of how serious the situation was. That morning's edition of the *Pittsburgh Post-Gazette* had nothing on the front page warning about potential flooding. "Nobody seemed too worried about it," Mrs. Stanny said. She was ninety-three in 2011 and lived in the Pittsburgh suburb of Baldwin Borough. That year marked the seventy-fifth anniversary of the flood.

Mrs. Sage, who was ninety-seven in 2011, agreed. "We didn't have a radio, and the young boys weren't selling special editions [of newspapers], so I really didn't know anything about a flood," she noted. When she left for work that morning from her home in Pittsburgh's Elliot neighborhood, she saw that parts of West Carson Street were under water. To her, that just meant that she couldn't hop a streetcar. Instead, she hoofed it across the West End Bridge to the North Side. When police forbade her from crossing the Allegheny River on any of the "Three Sisters" bridges at Sixth, Seventh and Ninth Streets, she realized that conditions were worse than she had thought. Undeterred, she finally managed to get across the river at Sixteenth Street.

Mrs. Sage, then Miss Kim and age twenty-one, worked as a bookkeeper, stenographer and sales clerk at a firm called Electrical Equipment Company on Smithfield Street. It was a few doors away from what was then Gimbels department store, now Burlington Coat Factory. When she arrived at work, she and other employees spent the rest of the morning moving inventory, records and office equipment to the second floor of the building. By that time, floodwaters had filled cellars on Smithfield Street and were approaching the first-floor door sills.

With electric power out and the threat of gas explosions from ruptured utility lines growing greater, police told her and her co-workers to leave. Realizing she could not get home, she called her aunt who lived in Morewood Gardens, an upscale apartment complex in Oakland, and made arrangements to stay with her. The apartments are now part of a Carnegie Mellon University dormitory area. With the trolley system closed down, Mrs. Sage hiked out Forbes Avenue to Oakland.

As she walked to her aunt's apartment, she realized that she hadn't eaten all day. She stopped at a Gammon's Restaurant—she recalled there being several eateries with that name around Pittsburgh—before finishing her trek. Some phones were working, and she was able to get a message to her mother telling her she was all right. To the best of her recollection, it was a full week before she could get back downtown to where she worked.

Mrs. Stanny, then Miss Simkunas, was eighteen in 1936, and she lived with her family on Forbes Avenue in Pittsburgh's Soho neighborhood. For her, the flood was mostly a few days of adventure combined with some mostly minor inconveniences. With the trolley system out of operation, she had to walk everywhere. "And I think there was a shortage of milk and bread at first," she recalled. Her family, however, didn't escape unscathed from the disaster's aftereffects. Her brother, Albert, suffered a serious eye injury from an explosion. That accident happened while he was working with a crew restoring electrical service to a Jones and Laughlin Steel Company plant, now demolished, on Second Avenue.

Flooding had been a periodic problem at the Point—where the Monongahela and Allegheny Rivers meet to form the Ohio—since the first white soldiers and settlers arrived in the 1750s. In March 1763, Captain Simeon Ecuyer, the commander of Fort Pitt, wrote a letter in which he described high water that turned the military post into an island and came within inches of requiring its abandonment.

Spring snowmelt and rains almost guaranteed that portions of the Point would be under water twice a year during most of Pittsburgh's history, Werner Loehlein said in a 2011 interview. A city native, he was chief of the water management branch of the Army Corps of Engineers for the Pittsburgh District for twenty years.

City officials had understood the dangers of flooding for decades. In April 1912, for example, the Pittsburgh Flood Commission, chaired by H.J. Heinz, had issued a one-thousand-page report. The study recommended construction of a series of dams and reservoirs upstream to reduce annual flooding. It wasn't until 1934 that the U.S. House approved flood-control measures for the Ohio Valley. The bill, however, stalled in the Senate.

The St. Patrick's Day flood was the result of a near-perfect storm of meteorological events, Loehlein said. Snowfall had measured sixty-three inches that winter, well above the average of forty to forty-five inches. After it quickly melted, it left the Mon and the Allegheny Rivers running full. Then the upstream watershed was hit with as much as two inches of rain, causing both rivers to flood at the same time. In 1936, sixteen feet was the normal level for the rivers at the Point. By March 18, the water had crested at forty-six feet.

Largely in reaction to the Pittsburgh disaster, the Senate finally acted to approve the Flood Control Act of 1936, Loehlein said. Congress delayed funding for another year, but downstream floods on the Ohio in January and March 1937 reinforced the need for the project. The federal government

ultimately financed construction of sixteen reservoirs to help control water in the upper Ohio Valley.

Those dams and reservoirs have proved their worth on multiple occasions. Floodwaters that flowed over the Point in June 1972, the result of Hurricane Agnes, measured about thirty-five and a half feet. "Without the reservoirs, the water level would have gone up to forty-eight feet—two feet higher than in the '36 flood," Loehlein said during an oral interview.

Will the city ever experience another disaster like the St. Patrick's Day flood? The probability is low, experts say, but it could happen again. "But there is no doubt that the reservoirs have reduced the frequency of flooding and reduced the height of flood crests," Loehlein said in 2011. He estimated that the flood-control measures can reduce water levels by as much as four feet and that there likely would have been substantial problems over the years without the controls.

The St. Patrick's Day flood provided stories for a lifetime—and more—of retelling. In 1936, Joseph Dury was fourteen and a student at Sewickley Academy, a private school about fourteen miles downriver from Pittsburgh. At some point on the morning of March 17, classroom clocks stopped and the lights went out, he recalled in a story he often told his wife, the former Peggy Watson. Mr. Dury died at eighty-seven in 2009.

As Mrs. Dury remembered it, her husband's mother had warned him about crossing the busy Pennsylvania Railroad tracks that separated Sewickley and Edgeworth from the Ohio River. So she was surprised to hear her son say that he and his classmates had been down to see the river on St. Patrick's Day. But there had been no need to cross the train tracks that day, Mrs. Dury said. The Ohio River was advancing up Hazel Lane, and her future husband and his friends could view the once-in-a-lifetime event from the edge of their campus.

2015: A NEW HOME FOR THE VENERABLE *GAZETTE*

When the first printing press arrived at the frontier village next to Fort Pitt in the late autumn of 1785, it was "a puny contrivance." That was how J. Cutler Andrews described the "small wooden hand machine" in his 1936 history of the *Pittsburgh Post-Gazette*.

Printers John Scull and Joseph Hall soon were using the secondhand English common press to turn out advertising fliers, blank business invoices,

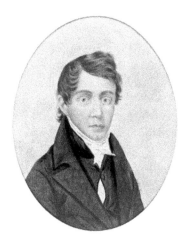

John Scull founded the newspaper known today as the *Pittsburgh Post-Gazette*. *Courtesy the* Pittsburgh Post-Gazette.

legal forms and books. Then, on July 29, 1786, the partners published the initial issue of the *Pittsburgh Gazette*. The weekly newspaper was the first such publication to be printed west of the Alleghenies. Its office stood near what is now the corner of Market Street and the Boulevard of the Allies in downtown Pittsburgh.

For the next 228 years, what became the *Pittsburgh Post-Gazette* was printed somewhere in the city's Golden Triangle. That changed in 2014, when the newspaper began publishing at a state-of-the-art printing facility in Clinton, west of Pittsburgh. In 2015, the editorial offices relocated to a new building near Heinz Field on Pittsburgh's North Shore.

Hall, sadly, died within months of the *Gazette*'s founding. His successor as Scull's partner, Philadelphian John Boyd, even more sadly, hanged himself, "without disclosing his reasons," according to Andrews's book, *Pittsburgh's Post-Gazette*. Boyd's death might have had something to do with the problems of putting out a publication on the Pennsylvania frontier, where "paper and printing materials had to be brought over the mountains on pack horses." When paper was in short supply, copies of the *Gazette* were published on sheets of writing paper and even on "cartridge paper of inferior quality" borrowed from the commandant of Fort Pitt.

With the rise of political parties in the young United States, Federalist John Scull, the editor and publisher of the *Pittsburgh Gazette*, soon found himself facing journalism rivals. The year 1800 saw the first issue of the *Tree of Liberty* newspaper. It was soon followed by the *Commonwealth* and the *Mercury*. All three supported Thomas Jefferson and his Democratic-Republican Party.

Scull, who served as editor and publisher for thirty years, was succeeded by his son, John Irwin, who briefly turned the paper into a semiweekly in 1816. The frontier publication went through several ownership and name changes in the 1820s but always retained at its root the word *Gazette*.

In 1829, the new editor, Neville B. Craig, ordered a technological wonder: a new imperial size, one-pull press that could handle larger sheets of paper. According to Andrews's book, the more efficient machine "created a great sensation among the populace when it arrived from Philadelphia."

Now that he had a modern press, editor Craig announced in 1831 that he planned to convert the *Gazette* into a daily newspaper. Longtime *Post-Gazette* editor Clarke M. Thomas wrote that it took months of "stop-and-go preparations" before daily publication began on July 30, 1833. Thomas was the author of a 2005 history of the newspaper, *Front-Page Pittsburgh: Two Hundred Years of the Post-Gazette.*

Craig and his successor, David N. "Deacon" White, continued to make other technological and news-gathering advances. "An evidence of increasing interest in the conduct of the government at Washington, D.C., was the employment in 1837 of a Washington correspondent, 'Junius' to retail political gossips from the capitol in the form of random letters," Andrews wrote. And in 1842, with "an eye to what was going on in Harrisburg, the paper dispatched a reporter there, too."

In 1845, White decided to replace Craig's hand-powered press with "a handsome one-cylinder Napier steam press built to order in New York at a cost of nearly two thousand dollars," Andrews wrote. Its modern value, as a capital project, would be close to $1 million, based on formulas developed by economists Lawrence H. Officer and Samuel H. Williamson.

A year later, telegraph service linked Pittsburgh to Washington, an innovation that allowed the *Gazette* to publish closing market prices from Baltimore, Philadelphia and New York. Many of the newspaper's 5,500 subscribers "were merchants residing in every quarter of the Ohio Valley…active business men in various walks of life," Andrews wrote. Russell Errett had become editor in 1856 as a new company, S. Riddle & Company, acquired the *Gazette.* Daily and weekly circulation rose to 12,000 copies by 1858.

During the Civil War, the *Gazette*'s Washington correspondent was well placed to cover the workings of the national government. The anonymous reporter worked from an office across the street from Willard's Hotel, just two blocks from the White House.

"Within three weeks after the war began the Gazette had appointed two correspondents to visit the volunteer Pennsylvania regiments and to write daily letters from the camps as long as the war lasted," Andrews wrote. The newspaper also combined efforts with a half dozen publications to form a Western Associated Press to supplement the coverage provided by the East Coast–based Associated Press.

Costs were up, but business was good. "Workmen are now engaged in putting in place for us one of Hoe's four cylinder presses, which is capable of printing 10,000 copies of the Gazette in an hour," the newspaper reported

on May 26, 1864. "Its purchase was rendered necessary by the large increase in our circulation which has almost doubled since our enlargement in the month of December last."

In the 1880s, the newspaper came under the control of Nelson Reed and his family. Those years saw the arrival of a popular columnist, Erasmus "Ras" Wilson, who wrote "The Quiet Observer" for a dozen years. Business manager Reed learned of the danger of tampering with reader favorites. "Once when it was hinted that [Wilson's] feature might be discontinued, the Gazette was deluged with so impressive a flood of indignant letters that the idea was hastily dropped," according to Andrews.

The late nineteenth century brought additional technological change. "In 1882 the Gazette directed public attention to its large new press, capable of printing fifteen thousand impressions per hour," Andrews reported. "Both sides of the paper could be printed at once, and each complete issue was cut, pasted and folded before leaving the press."

Two years later, the *Gazette* bought its first Mergenthaler linotype machine. That labor-saving device meant that type no longer had to be set and justified—placed in even columns—one letter at a time.

In 1900, the Reed family sold out to an investment group led by businessman and politician George T. Oliver. The search for new technology continued with a faster press in a new headquarters on Virgin Alley, now Oliver Avenue, in the block behind First Presbyterian and Trinity Episcopal Churches.

The faster press and faster typesetting were critical as papers got thicker, and circulation briefly increased to 140,000 by 1907 after the newspaper took over a rival and became the *Gazette Times*. Then, around 1908, spot color arrived. "Sober citizens along Fifth Avenue gazed in wonder at red-ink streamer headlines flung across the top of the Gazette Times," Andrews wrote. "The explanation was that a new press with a red ink attachment had just been purchased."

Oliver was curiously publicity-shy for a politician. Although he had been serving as a U.S. senator since 1909, his picture never appeared in his newspaper until 1911. A foe of what he called "trombone journalism," Oliver had to be convinced that his image belonged with a story about the 125th anniversary of the founding of the *Gazette*. "For the greater part of one afternoon the energies of the whole office were applied to convincing him that the editor was right in publishing the picture," Andrews wrote.

The *Daily Morning Post*—the other half of the name of the modern newspaper—had published its first daily edition on September 10, 1842.

For the next eighty-five years, under a variety of owners and editors, the *Post* would trade shots with the older *Gazette*. "The paper's Democratic and pro-labor policies provided an important foil to the Gazette's Whiggish, and later Republican, tendencies," Thomas wrote in *Front-Page Pittsburgh*.

Those decades of acrimony made the brief courtship and merger of the *Gazette-Times* and the *Pittsburgh Post* the most unlikely of matches. The powers behind the two-step process were William Randolph Hearst and Paul Block. The two men were sometimes rivals and sometimes friends. Thomas devotes an entire chapter in *Front-Page Pittsburgh* to describing the complex deal the two newspaper giants worked out.

The agreement first called for Block to acquire the *Post* and *Sun*, while Hearst would buy the *Gazette Times* and *Chronicle Telegraph*. The second step was a near simultaneous trade between the two newspaper proprietors: Hearst would take ownership of the *Chronicle-Telegraph* to form the *Pittsburgh Sun-Telegraph*, and Block got the *Gazette Times*. He merged that paper with the *Post* to create the *Post-Gazette*. That deal, signed on August 1, 1927, marked the start of the Block family's thus far three-generation ownership of the *Post-Gazette*.

Less than a decade later, in 1936, Paul Block was making plans for a new plant at the corner of Grant Street and Boulevard of the Allies. When the sixty-five-thousand-square-foot building opened on March 9, 1938, Block had hopes that President Franklin Roosevelt would be present to press the button and start the presses. His friend, President Calvin Coolidge, had performed that act when Block had opened a new plant for the Toledo Blade. As Thomas told the story in *Front-Page Pittsburgh*, the president declined to come to Pittsburgh because he was still steaming about a *Post-Gazette* series by Ray Sprigle. The Pulitzer Prize–winning stories revealed the earlier Ku Klux Klan membership of recently confirmed Supreme Court justice Hugo Black, a Roosevelt appointee.

Additional newspaper consolidation lay ahead. Paul Block died in 1941, and it fell to his sons, William and Paul Jr., to oversee the 1960 acquisition of the *Sun-Telegraph*. That takeover meant a move from the 1938 printing plant four blocks north on Grant Street to the *Sun-Telly's* more modern pressroom. That building stood at the site of the U.S. Steel Tower.

Rising losses at the combined newspapers led to talks between the Block brothers and Scripps-Howard, which had owned the *Pittsburgh Press* since 1924. A joint operating agreement took effect in November 1961 that saw the *Post-Gazette* editorial staff relocating once again, this time to the fourth floor of the *Press* building at 34 Boulevard of the Allies.

May 1992 saw the start of an eight-month-long labor dispute that ended with Scripps-Howard announcing plans to sell the *Press* and its acquisition by what is now called Block Communications Inc. The *Post-Gazette* editorial staff moved into the former *Press* offices, and the surviving newspaper continued to be printed at that location on upgraded Hoe presses. While they were modernized in 1997 and again in 2004, the original presses dated to the 1950s. In 2013, the *Post-Gazette* announced that it was buying new high-capacity printing press equipment from Goss International. "The Pittsburgh Post-Gazette's commitment to Pittsburgh and my elation with this announcement have no bounds," John Robinson Block, publisher and editor-in-chief, said of the company's plans.

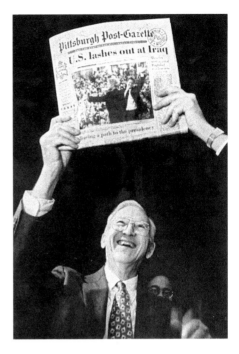

Publisher Bill Block Sr. holds a copy of the first *Post-Gazette* printed in 1993 after the settlement of a prolonged strike. *Courtesy the* Pittsburgh Post-Gazette.

At the same time that Block Communications was updating its presses and moving to new offices, the company also introduced a state-of-the-art publishing system called Libercus. The Cloud-based system was designed to allow the seamless delivery of news and advertising to readers via newspapers, websites and mobile devices.

In 2015, *Post-Gazette* products, including the region's most visited website, reached nearly 1 million people each week. "We have a vast, vast audience that spans the whole world," John Robinson Block has said.

"John Scull would probably view with approval the fact that the name Gazette is still carried at the masthead," Andrews wrote in the last chapter of his history of the region's oldest newspaper. He went on to speculate that the paper's first editor also would have to admit that "his successors have kept the paper in the line of its tradition by presenting a dignified brand of journalism and by consistently striving to advance the best interest of its community of readers."

EVERYBODY COMES TO PITTSBURGH

1842: DICKENS OF A TIME

Pittsburgh lawyer Charles B. Scully described "a remarkable event" in his diary for March 29, 1842. "Went to the Exchange Hotel and was shown up to room No. 12," he wrote. After Scully announced his name, he "was introduced to Mr. Charles Dickens, the greatest author of the age." Dickens and his wife, Catherine, known as "Kate," spent three days in Pittsburgh in the spring of 1842 as part of a tour across America. Although he was only thirty when he visited the city, Dickens was already famous across the English-speaking world as the creator of *The Pickwick Papers* and *Oliver Twist*. On a trip that took him from New England to the South, he was gathering material for a work of nonfiction called *American Notes*. Scully's meeting with Dickens was the subject of a retrospective news story in the August 26, 1917 edition of the *Pittsburgh Gazette Times*.

Coming west across the Allegheny Mountains, Dickens and his wife traveled to Pittsburgh via the most up-to-date mode of transportation: a thirty-six-mile-long portage railroad between Hollidaysburg and Johnstown. The portage railroad linked two sections of the Pennsylvania Canal. It made use of parallel railroad tracks that climbed up steep hillsides, creating a series of ten inclined planes. The devices were similar to Pittsburgh's Monongahela and Duquesne inclines, both of which are still in use. Small stationary engines at the top of each plane would haul up and lower down counterbalanced cars. The route had been laid out with

Charles Dickens, pictured at his country home, was not impressed with smoky Pittsburgh when he visited in 1842. *Courtesy Library of Congress.*

relatively flat areas between the sloping planes where rail cars could be moved by horses or locomotives.

Dickens found that the technology made for a sometimes frightening journey. "Occasionally the rails are laid upon the extreme verge of a giddy precipice," he wrote in *American Notes.* Looking out "from the carriage window, the traveler gazes down, without a stone or scrap of fence between, into the mountain depths below."

When the views were not frightening, the scenery was pleasing. "It was very pretty, traveling thus at a rapid pace along the heights of the mountain in a keen wind," he wrote. Travelers "could look down into a valley full of light and softness, catching glimpses through the tree tops of scattered cabins." Transported by the cutting-edge technology of locomotives, canals and inclined planes, Dickens and his wife were able to travel from Harrisburg to Pittsburgh in just four days. The author, however, was not impressed when he arrived here by water on the evening of March 28, 1842.

The sight of "furnace fires" and the sound of "clanking hammers on the banks of the canal" alerted travelers that they were approaching the city. Their canalboat carried its passengers across the Allegheny River in a

covered aqueduct. Dickens described it as "a vast, low wooden chamber" in *American Notes*. "We emerged upon that ugly confusion of backs of buildings and crazy galleries and stairs which always abuts on water and were at Pittsburgh." While the city was often compared to Britain's Birmingham, Dickens found that the two had little in common except that Pittsburgh, like its English cousin, "had a great quantity of smoke hanging about it, and is famous for its iron works."

The author had kinder words for the hotel where he and his wife stayed during their three-day visit. The Exchange Hotel stood at the corner of what is now Penn Avenue and Sixth Street. "We lodged at a most excellent hotel, and were admirably served," he wrote.

When Scully was introduced to Dickens the morning after his arrival, he found the writer to be "very fidgety." Both Dickens and his wife had read about steamboat explosions, according to the 1917 *Gazette Times* story. "I recommended [to Kate Dickens] to take a boat with Evans' safety valves, and she said she would," Scully wrote in his diary for March 29.

The couple's next stop was Cincinnati, and on the morning of April 1, Dickens and his wife left for Ohio aboard a steamboat named *Messenger*. That vessel had been "best recommended," although Dickens was amused by its captain's apparent indifference to printed schedules. The captain "had been advised to start positively [for Cincinnati] every day for a fortnight or so, and had not gone yet," he wrote. The couple arrived safely at their destination on April 4. "It is consoling to know that the Messenger did not blow up," the *Gazette Times* story concluded.

1869: COULD THIS "LITTLE MAN" BE PRESIDENT GRANT?

When Ulysses S. Grant arrived in Washington to take command of the Union army in 1864, no one was there to greet him. "Inconspicuous and unrecognized, a travel-stained linen duster hiding most of his uniform, he made his way to the Willard Hotel," Jean Edward Smith wrote in his 2001 biography of the Civil War general.

When President Grant arrived in Pittsburgh five years later, something similar happened. The president's train was late, and many people in the crowd gathered at Union Station began to scatter, according to the September 15, 1869 edition of the *Pittsburgh Gazette*. A few minutes

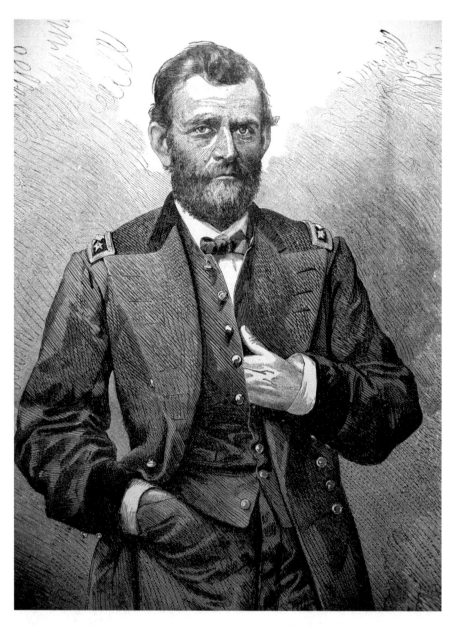

Ulysses S. Grant looked too short to be the president according to one Pittsburgh resident. From *Harper's Pictorial History of the Civil War, Part First. Courtesy Senator John Heinz History Center.*

later, "the special train came thundering into the depot," the newspaper noted. "The President stepped out alone and was not recognized by anyone until he had passed nearly through the depot." At that point, U.S. Representative James K. Moorhead, spotting Grant, "quietly took charge of him and conducted him to a carriage." Newspaper accounts disagree on what kind of reception Grant received as he rode from the station on Liberty Avenue to the Monongahela House on Smithfield Street.

The *Pittsburgh Daily Post*, which billed itself as "The Only Democratic Daily Paper in Western Pennsylvania," claimed that Grant, now identified with the "Radical" Republicans, was snubbed by most local politicians and ignored by the general population. "He must have felt humbled yesterday on his entrance to this…city," a brief story in the September 15 edition of the *Post* said. The president's party filled only two carriages, the *Post*'s reporter wrote, and he claimed that he had not heard even a single cheer "of welcome from the depot to the Monongahela House."

The *Pittsburgh Evening Chronicle* and the *Gazette*, both friendlier to the GOP in their editorial policies, reported that once Grant had been located, twelve carriages were needed to ferry the president, his family and local dignitaries to the hotel. "The crowd at the depot was very large and enthusiastic, and the President was loudly cheered along the route," the *Chronicle* reported on September 14, the day of Grant's arrival.

The *Post* also made fun of Grant's shortcomings as a public speaker. On the day of his arrival, the *Post* provided a mock version of what Grant would say: "Gentlemen of the Committee I thank you for your cordial reception. I came to see your people and stay with you a short time. I like Pittsburgh." The *Post*'s prediction was pretty close. Speaking from the balcony of the Monongahela House to the crowd gathered on Smithfield Street, Grant offered brief thanks for the noisy reception and ended with a joke: "It is unnecessary for me to say more, as many of you cannot hear what I am saying."

The next morning, Grant and his family left by carriage to visit cousins William McKenna and William Wrenshall Smith in Washington County, Pennsylvania. The day after Grant's departure, the *Gazette* ran a short story based on a familiar trope: that the president had gone unrecognized once again.

As the Grant family headed south, they came up to a "tall lank fellow" who asked when the president was expected to pass by. "Mrs. Grant quickly said, 'This is the president.'" The man by the road was skeptical. "Get along

Missus…that man's good enough, but I'll wait a little longer to see our President. That little fellow won't pass for him just this time."

The president "laughed heartily," the newspaper reported, and he rode on toward Washington County.

1884: MARK TWAIN FINDS A NEW ADDRESS FOR HELL

Mark Twain claimed to have "a horror of interviewers," but he made himself available to one when he visited Pittsburgh in 1884. Twain, whose real name was Samuel Langhorne Clemens, was following the example of other writers and platform speakers who made Pittsburgh an important stop on their speaking tours.

The Adventures of Huckleberry Finn, Twain's masterpiece about moral courage and cowardice set along the pre–Civil War Mississippi, was days from publication in the United States when its author lectured in Pittsburgh. Twain was the senior partner in a double act with George Washington Cable. Cable was the author of southern realist novels that often took place in his native Louisiana.

Although tired after his train ride from Philadelphia, Twain invited a reporter from the *Pittsburgh Daily Post* to talk with him in his room. Twain was staying in the Monongahela House, the city's fanciest hotel. The story that appeared in the *Post*'s December 30, 1884 edition suggests that Twain was not so much interviewed as given an opportunity to tell well-worn anecdotes and throw out one-liners. "Ever since I knew anything, I have had a horror of interviewers," he told the anonymous scribe. "The principal reason of that is that reporters have a way of getting at facts that a man does not want known."

Twain said that one reporter had coaxed him into discussing a crime that the novelist had committed. "What the crime was has entirely escaped my memory," Twain claimed. "I have been guilty of so many that I can't keep track of any particular one." The *Post*'s reporter pressed him on why he decided to get back on the lecture circuit after vowing eight years earlier never to return. "But they say lecturers and burglars never reform," Twain joked. "As he closed this remark, [Twain] looked longingly toward a gorgeous nightshirt that was hanging over the footboard of the bedstead," the *Post* story said. At the same time, Twain reminded the reporter that he had had "a very tiresome ride." The *Post*'s writer got the message. "It would have been cruel not to have noticed these evident signs of distress and the reporter retired," the *Post*'s story concluded.

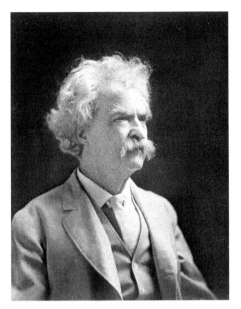

Mark Twain, photographed in 1907, was already a celebrated lecturer when he spoke in Pittsburgh in 1884. *Courtesy Library of Congress.*

The next day was Twain's and Cable's joint reading. Cable joked that being introduced by the disreputable Twain would have made it "rather a doubtful experiment for him to appear as a reputable individual," the *Pittsburgh Commercial Gazette* reported on December 30. Instead, the younger author said he would introduce himself. He explained "for the benefit of the audience that he was Mr. Cable and the person who would follow him was the other man."

While it had been announced that Twain would read from the manuscript of his latest work, *Huckleberry Finn*, it is unclear from the *Gazette* story whether he did so. There was a published program for the authors' readings, but "it was one of the jokes of the evening" that Twain declined to follow it.

Twain was forty-nine and showing some signs of age when he and Cable appeared at Pittsburgh's Cumberland Presbyterian Church. The church was located where the Duquesne Club now stands on Sixth Avenue. Twain had a head of bushy gray hair and a matching bristly mustache. "He spoke with great seriousness and deliberation, most solemn when he is delivering his greatest absurdities," the *Gazette* reported.

Twain told a reporter from the *Pittsburgh Daily Post* that after their readings, he and Cable visited Mount Washington, which looms above Pittsburgh, to get "a bird's eye view of your city by moonlight." "With the moon soft and mellow, we sauntered about the mount and looked down on the lake of fire and flame," Twain was quoted in a *Post* story that appeared December 31. "It looked like a miniature hell with the lid off." His remark echoed one famously written sixteen years earlier by James Patton in the *Atlantic Monthly* magazine. "The view is not as deliciously beautiful as one would suppose," Twain said to the local reporter. "If one can be calm and resolute, he can look upon the picture and still live. Otherwise, your city is a beauty."

1890: GLOBE-TROTTER NELLIE BLY RETURNS

Globe-trotting journalist Nellie Bly was not superstitious. An anonymous scribbler for the *Pittsburg Press* had hopped aboard her train at Columbus, Ohio, on the evening of January 24, 1890. The Pennsylvania Railroad "special" was carrying her to New York, via Pittsburgh, on the final leg of her around-the-world trek.

Her trip had been sponsored by Joseph Pulitzer's *New York World*. The *Press* reporter wrote on January 25 that he and the *World's* J.J. "Snowshoe" Jennings were the only two journalists invited to travel with Ms. Bly on the end of her journey. He found the twenty-five-year-old reporter "lounging" in drawing room no. 13 of the luxurious "Ilion" Pullman car. He described it as "one of the handsomest and most perfectly constructed" sleeping and lounge cars operating on the Pennsy's Pittsburgh, Cincinnati, Chicago & St. Louis line.

Bly told him that she was not in the least bothered by the "unlucky" number of her drawing room. "Your Press [ID] badge is [number] 13," she observed, offering to borrow it. "I'll wear it to New York and return it." It was fortunate that Nellie Bly didn't have triskaidekaphobia, the scientific name for fear of that number. The reporter told her he had arrived at Columbus's Union Station on the no. 13 bus and that thirteen different railroads converged on that Ohio city. "Good," she said. "I love the No. 13."

Bly was scheduled to arrive at Pittsburgh's Union Station at 3:00 a.m. on January 25. (The station has since been converted into the Pennsylvanian apartment building.) As her train sped through the Ohio darkness, she "retired to her private apartment for a little rest before reaching Pittsburg." The *Press* was an early adopter of the decision by the U.S. Board of Geographic Names to standardize the spelling of American place names by removing the letter *h* from communities ending with "burgh." Other papers continued to use the traditional spelling.

Traveling on the same train as Bly was an unidentified Pittsburgh factory owner. He advised the *Press* reporter that the young woman's around-the-world trip was more than a stunt but had practical value. Andrew Carnegie had started a similar journey in 1878 that put him out of touch with his business interests for long periods of time. Bly's lightning-fast seventy-two-day circumnavigation "actually established a standard schedule which may be of inestimable value to many globe trotters...in the future," the unidentified businessman said.

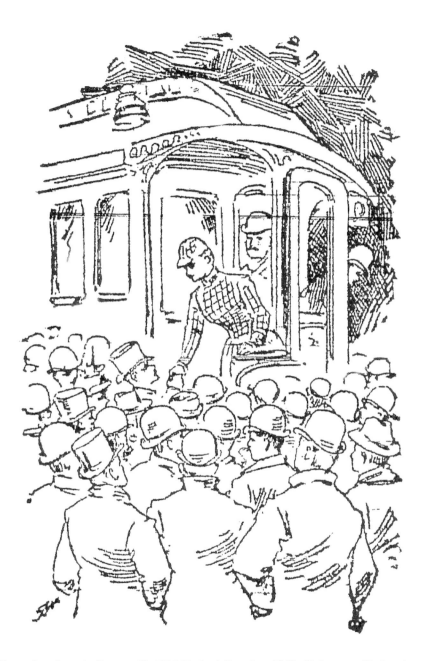

Illustrations from the January 25, 1890 *Pittsburgh Press* show Nellie Bly's stop at Pittsburgh on the last morning of her trip around the world.

Bly rejoined reporters sometime after midnight for a late meal. "There is the Ohio," she said, looking out the train window at the river. "I am nearing dear, old Pittsburg." Bly had begun her newspaper career a few years earlier on the *Pittsburgh Dispatch*.

Her train reached Pittsburgh's Union Station right on time. "A hearty cheer greeted Miss Bly as she appeared on the rear platform of her car," the *Press* story said. "She was immediately embraced by some of her relatives and greeted by intimate friends. She then joined the coterie of Pittsburg newspaper men, who gave her a cordial and congratulatory reception."

"Although she had succeeded in skimming around the globe in the fastest time on record, the achievement had not affected her the least bit," the *Pittsburgh Commercial Gazette* reported in its January 25 edition. "She was the same bright-eyed girl who used to hustle…in this city, with a cheery greeting for every friend and an eager desire to gather in any stray gems of thought.

"Nellie, when she appeared on the platform of the car, was attired in a long traveling coat, which reached to her feet, and a jaunty little traveling cap, which was saucily set to one side of her head. She looked the picture of health…. 'I am feeling splendid,' said Nellie. 'I am not in the least fatigued and have had good luck during my entire trip. I kept myself awake on my way to this city as I wanted to see my old home and to meet my old friends.'"

While her own health was good, she told her friends she was concerned about a pet monkey, named McGinty, that had been given to her by a rajah in Singapore. "I fear the little fellow has the grip," she told reporters. The "grip," sometimes spelled "grippe," is an earlier term for the flu.

Her trip around the world was a race not only against the fictional Phileas Fogg, the hero of Jules Verne's *Around the World in 80 Days*. She was also facing a real-life competitor named Elizabeth Bisland. Bisland's editors at a magazine called *Cosmopolitan* had sent her west on a 'round-the-world journey within a few hours after Ms. Bly's ship, traveling east, left for England.

As the two women hurried around the globe, their paths never crossed. For much of the next two months, it appeared that Bisland would beat Bly back to New York, but Bly's rival missed a final crucial connection in France. Bisland would still be at sea when Bly returned to New York that same afternoon.

Nellie Bly sent a two-sentence dispatch about the end of her journey that was printed on January 26 in the Sunday edition of the *Pittsburg Press*. "Arrived at 3:51 p.m. and was greeted by 20,000 friends," she wrote. "Time of trip—72 days, six hours, 11 minutes."

1913: "Cougar" Ellen Terry Loses Her Cub

A secret May-December wedding performed in Pittsburgh ended sadly after six years. "Ellen Terry, the actress who was long the leading woman of Sir Henry Irving, and her husband, James Carew, have separated by mutual consent," the *Pittsburgh Press* announced in its edition of July 6, 1913. Terry, born in 1847, was sixty-six; her estranged spouse was thirty-seven. "By agreement, Carew will keep their costly furniture," the newspaper told its readers.

Terry and Carew were wed in Pittsburgh on March 22, 1907, while both were appearing in a play at the Nixon Theater. "The ceremony was performed in the presence of but three persons, who were bound to secrecy until Miss Terry had finished her American tour and sailed for London," according to the *Press* account. The couple had been on stage in Chicago when they decided to tie the knot. Carew asked a Chicago lawyer to set up arrangements for a secret Smoky City wedding when their touring company came east. Pittsburgh attorneys James R. Bell and Benjamin H. Thompson "enlisted the services of Marriage License Clerk George W. Watson, with whom it was arranged that the couple should appear before him after office hours and get their license."

"Issued in this manner, the license escaped newspaper notice," the *Press* said. The cloak-and-dagger atmosphere continued as the two lawyers took the couple to the office of a mutual friend where the thespians would take their vows. "There Justice of the Peace George J. Campbell of Bellevue was called in and in a few minutes the ceremony was performed."

It was the first marriage for Carew. "When asked how many times she had been married, Miss Terry said, 'Do I have to answer that question in this state?' When told it was the law, she said 'Well, I have been married twice before. My last husband was Mr. Wardell. My name is now Ellen Alice Wardell. Now don't ask me any more.'"

There were more questions, however. "To complete the records, however, Miss Terry found it necessary to tell her age, which was placed at 59, and to relate that she parted from her first husband by divorce, and from her second by death," the story said. "She said her first marriage had been a mistake." So was her age. Miss Terry had marked her sixtieth birthday three weeks earlier on February 27, 1907.

Her first marriage was to an artist named George Frederic Watts. Her late husband was an actor, Charles Wardell. Following the end of her marriage to Carew, Terry continued to tour and, later, to make silent movies. She died in 1928.

Terry had been a frequent visitor to Pittsburgh. During a tour stop in 1900, her character and her performance as Portia in Shakespeare's *Merchant of Venice* received a mixed review from a young journalist named Willa Cather. Terry's leading man was Sir Henry Irving, playing Shylock. Cather went on to write a dozen highly regarded novels. Cather described Terry as having on stage "that strange combination of sentiment and comedy, of witchery and mirth, of carelessness and happy intuitions," in a story that appeared on February 17, 1900, in the *Pittsburgh Courier*. Cather's journalism, edited by William M. Curtin, has been collected in a two-volume anthology called *The World and the Parish*.

Too indolent to study her lines, Terry "dares to improvise in the 'quality of mercy' speech," Cather wrote. Yet her Portia is "done regally and blithely and to the tune of silver bells.... [Her] laugh that is half a sigh, coquetry that is half pure enchantment, comedy in the summer moonlight, that is Miss Terry's own art."

1927: *Show Boat* Wows Pittsburgh Critics

Pittsburgh theater critics knew they had experienced something unique when *Show Boat* dropped anchor at the Nixon Theater. The groundbreaking musical, based on a bestselling novel by Edna Ferber, had music by Jerome Kern and lyrics by Oscar Hammerstein.

Neither Florence Fisher Parry, the *Post-Gazette*'s reviewer, nor Karl B. Krug, her counterpart for the *Pittsburgh Press*, could find much of anything wrong with the preview performances. Pittsburgh was then a frequent stop during tryout tours for shows preparing for their Broadway openings.

"By order of the county commissioners, the Citizens' league and all the other official bodies that may happen to be officiating at the moment, Pittsburgh and Allegheny County playgoers in this week of Thanksgiving are ordered to drop to their knees and offer up their most fervid gratitude for Florenz Ziegfeld's 'Show Boat,'" Krug wrote on November 22, 1927. A breathless Parry that same day said the musical was "operetta and vaudeville and drama all heaped into one great avalanche of splendor—an avalanche which bore down upon the gasping Nixon audience last night with a deep roar of conquest, sweeping before it all precedent in theatrical production and establishing a new, gigantic pace in entertainment."

Show Boat broke ground in multiple ways. Following the plot of the Ferber novel, it combined broad comedy with romance and drama. The show had an integrated cast. The plot includes what turns out to be an interracial

love affair. In a score that contains many numbers still performed today, the best-known song, the show-stopper "Ol' Man River," was given to a black deckhand. While the song and the role of Joe eventually came to be identified with actor and political activist Paul Robeson, the part was played on the tryout tour and in the Broadway opening by Jules Bledsoe. The *Post-Gazette*'s Parry said he gave "the truly beautiful performance of the evening." Bledsoe, she wrote, "boosts the current stock of Negro talent with his unpremeditated skill." As it turns out, there was a lot of "premeditation" in Bledsoe, who had studied with several New York voice teachers and sang major roles with opera companies in the United States and in Europe.

While the Pittsburgh reviews were generally rapturous, both critics had suggestions for producer Florenz Ziegfeld. "It is in length that Ziegfeld faces his problem," Krug wrote. "The play must be cut, although where to do it is the question." While Krug found that Howard Marsh, playing the gambler Gaylord Ravenal, gave an outstanding performance, the *Post-Gazette*'s Parry was not impressed. "My appraisal of Mr. Marsh, who invariably is given the most envied of male roles, is negligible," she wrote. "I find him totally without charm."

The top ticket cost $4.40, equal to about $55.00 in today's currency. "We got our money's worth—but when, Mr. Ziegfeld, will you ever get yours, at this rate?" Parry wrote. "You fling the public's gladly given money right back at it, in a 'Show Boat' that would make any other showman show-broke."

When *Show Boat* opened on December 27 in New York, it proved a similar hit with critics and the public. Two movie versions followed. Modern productions of the show, however, have faced controversy. Its critics say that *Show Boat* reinforces black stereotypes and, even with dialogue changes, contains some language demeaning to African Americans.

1932: CHURCHILL OFFERS AN EARLY WARNING

Years before Winston Churchill memorably spoke of the "special relationship" between the United Kingdom and the United States, he told a Pittsburgh audience that the two nations had a common role to play in keeping the world prosperous and at peace.

One key was maintaining a strong military. "Of course, the English-speaking people of the world are all in favor of disarmament, of peace between the nations," Churchill said to a crowd of one thousand. "But how

tragic it would be, if, after a protracted program of disarmament, we were to learn that the English-speaking peoples were the only ones so anxious about peace." His speech in Oakland's Carnegie Music Hall on March 7, 1932, came during his only visit to Pittsburgh. The event was covered in the *Pittsburgh Post-Gazette* the next day.

He spoke in Pittsburgh nine months before Adolf Hitler became German chancellor. The Nazi leader soon embarked on an arms buildup and war policy that by 1941 had united America and Britain in a common defense of Western values. During most of World War II, Churchill served as Britain's prime minister. After the war, he used the phrase "special relationship" in several speeches, including his "Iron Curtain" address at Fulton, Missouri, in 1946.

Churchill was one of many visitors to Pittsburgh who, over the decades, helped heal the rifts created by two early wars between the United States and Great Britain. When Churchill visited the city as part of a lecture tour, he was no longer in government. He was widely known as a prolific writer and knowledgeable commentator, but he was also seen by many as a washed-up politician. His 1932 stop in Pittsburgh brought him to the city named for one of his most distinguished predecessors in Parliament: William Pitt the Elder. General John Forbes named the settlement at the forks of the Ohio for Pitt, who directed the British government during much of the French and Indian War. Arriving here in November 1758 at the head of a combined British and colonial force, General Forbes drove the French from what would become Pittsburgh's Point. The success of General Forbes in capturing the ruins of Fort Duquesne, however, may have marked the high point of British-colonial and later British-American cooperation for the next 150 years.

Relations between American colonists and the mother country already had begun going south in 1755 when another British general, Edward Braddock, had been trounced by a combined French and Indian force. After General Braddock was defeated only about seven miles east of the Point, settlers complained that the Pennsylvania frontier had been left without defenses. Things got worse after 1763 when King George III declared that lands west of the Allegheny should be closed to more colonial settlers.

The American Revolution permanently split the mother country from its colonies. Even after that war formally ended in 1783, the threat of renewed violence remained. The British had failed to withdraw from forts in the Ohio Country claimed by the United States. In response, Congress had "come to a determination of raising troops for the purpose of taking the western forts withheld by the British," the *Pittsburgh Gazette* reported in its August 26, 1786

Winston Churchill, as he appeared in 1932, spoke to one thousand people at Pittsburgh's Carnegie Music Hall on March 7 of that year. *Courtesy the* Pittsburgh Post-Gazette.

edition. While the dispute dragged on for another ten years, it ultimately was settled peacefully.

The two countries, nevertheless, were once again at war in 1812. The fledgling United States still hoped to conquer British Canada, although that effort failed disastrously, but not until several Canadian and U.S. cities—including Washington, D.C.—were burned. That conflict effectively ended in a draw with bad feelings all around.

In the aftermath of two wars, British-American relations remained cool at best. The situation was not helped by events like the 1842 visit by thirty-year-old Charles Dickens, already Britain's most popular novelist. The author was impressed by western Pennsylvania scenery but not by the "ugly confusion" of smoky Pittsburgh.

As North and South headed closer to Civil War—mostly over the issue of slavery—Great Britain saw its interests aligning more with the Southern states. That region provided cotton for British mills, and its wealthy planters were consumers of British manufactured goods. That made for frosty feelings between the two largest English-speaking nations. However, in 1860, a young man's visit to Pittsburgh helped warm up that relationship.

The identity of the eighteen-year-old Englishman traveling to the United States under the title Baron Renfrew was a badly kept secret. The "baron" had been christened Albert Edward at Windsor Castle shortly after his birth in 1841 to Queen Victoria. He was Prince of Wales and heir to the British throne. Pittsburgh was one of his stops on an unofficial tour of North America. He arrived on October 1, 1860, at Allegheny City's railroad depot on what is now Pittsburgh's North Side.

The young man, who later reigned as King Edward VII, was the first member of the royal family to visit the former British colonies, and the *Daily Pittsburgh Gazette* reported that he made a favorable impression. He stayed overnight in the city's finest hotel, the Monongahela House on Smithfield Street. The next morning, he traveled by open coach to the Pennsylvania Railroad station, giving residents plenty of opportunity to observe him but not get too close. As he left the hotel, a cavalry escort from the Duquesne Greys militia and Young's Brass Band, "defiling on each side of the carriage, formed an escort of honor to the Prince and checked the inconsiderate curiosity of the crowd."

"As the cortege passed along the streets, it is needless to say the Baron Renfrew was the person upon whom all attention centered," a reporter for the *Gazette* wrote on October 3. "The ladies in particular smiled benignly on him and waved their handkerchiefs, and he invariably responded to their attentions by bowing and lifting his hat."

"His face did not indicate a great amount of intellectuality nor the want of it," according to the paper. "His features were good, with a little cast of the German in them, and his person was graceful." The reporter also was struck by his ordinariness. "He looked much like other young men brought up in good society, and there was nothing about him to indicate he is the heir apparent of the English throne."

The same week in 1860 that Albert Edward, the Prince of Wales, visited Pittsburgh, his image was on the cover of *Harper's Weekly. Courtesy Library of Congress.*

Pittsburgh would have to wait 128 years for another visit by a Prince of Wales. In March 1988, Prince Charles, the son of Queen Elizabeth and current heir to the throne, was the keynote speaker at a Remaking Cities conference. He arrived during a late winter snowstorm. By the time his limousine reached downtown, the city's celebrated view at the end of the Fort Pitt Tunnel was lost in a blinding blizzard, the *Post-Gazette* reported. While Pittsburghers were disappointed that Charles had not brought along his wife, Diana, the longtime heir-apparent generally charmed the people he met with during his overnight stay in Pittsburgh.

Even more so than visits by princes, an event that took place less than a year before the start of World War I helped to usher in a new era in British-American relations. That was when British officers came to southwestern Pennsylvania to honor one of their own: the doomed General Edward Braddock. General Braddock had been wounded on July 9, 1755, during a battle in what would become the borough named for him. The unlucky general died on July 13, about seven miles southeast of present-day Uniontown, and was buried in an unmarked grave.

On October 15, 1913, Fayette County residents, state officials and members the Coldstream Guards, Braddock's old regiment, gathered to dedicate a granite monument and bronze plaque to his memory. General Braddock's remains had been reburied there in 1804.

About one thousand people met the noon train carrying British officers when it arrived at Uniontown's Pennsylvania Station, according to the next day's edition of the *Pittsburgh Gazette*. Correspondent George A. Campsey reported that someone in the crowd yelled, "The Red Coats are coming" as the train pulled in.

The new monument had been erected along Route 40 in what was called Braddock Memorial Park. Getting there from Uniontown required a hike or slow ride up Chestnut Ridge, and the *Gazette*'s reporter wrote that some people had started out for the afternoon ceremony as early as 5:00 a.m. "Many entire families took a holiday to attend the dedicatory exercises and the park took the form of a sort of picnic ground early in the day," he wrote. About five thousand people made the trek. Former secretary of state Philander Knox, the main speaker, scored points with the British contingent when he assured them that the United States no longer had any designs on Canada.

Lieutenant General Sir Alfred Edward Codrington, a former colonel in the Coldstream Guards, talked about the common history, common language and similar flags of the United Kingdom and the United States. "It is indeed a

happy omen that we have here today flags—of different nations—yet you see in them the same red, white and blue," he told the crowd.

The outdoor program was followed by a banquet for 125 guests at the nearby Summit Inn, which still is in operation along Route 40. The multiple toasts offered at the dinner included one from Pennsylvania governor John K. Tener that summed up the tone of the day's events: "At Peace with the Mother Country."

By the time Churchill arrived in Pittsburgh in 1932, the United States and United Kingdom had fought as allies in World War I. There was, nevertheless, still suspicion among many Americans, especially Irish Americans and German Americans, about "perfidious Albion."

Concerns about Churchill's security meant that he would "be constantly accompanied by a police escort from the time he arrives at the Pittsburgh & Lake Erie depot early today until he leaves Pittsburgh after he lectures in Carnegie Music hall tonight," the *Post-Gazette* reported on March 7, 1932. "The guard was deemed advisable to protect him from cranks."

In addition to warning about the dangers of too many defense cuts, Churchill talked about ways the United States and Britain could together fight the worldwide Depression, according to a March 8, 1932 story in the *Post-Gazette*. Moving to another issue, he opined that high taxes, rather than prohibition, offered a better way to deal with alcohol abuse.

Both Britain and the United States had much they could learn from each in terms of improving their economies and governments, he told a reporter for the *Pittsburgh Sun-Telegraph*. Such advice, however, was unlikely to be followed. "But English-speaking people are apt to be obstinate," Churchill said in a story that appeared on March 8 in that paper. "Tell them to go one way and they are certain to go the other."

1934: HE WAS NO EINSTEIN AT PREDICTIONS

When Albert Einstein was quizzed about his theories by Pittsburgh newspaper reporters, he wasn't afraid to admit uncertainty. A series of five images of the Nobel Prize–winning physicist accompanied one *Pittsburgh Post-Gazette* story about his 1934 visit to the city for a scientific conference. "These portrait photographs show him first, listening eagerly; next, getting a gleam of insight into the questions; third, explaining slowly and patiently; fourth, making his point clear; and last—the smile itself."

Albert Einstein told a Pittsburgh audience in 1934 that splitting the atom would be as hard as "shooting birds in the dark in a country where there are only a few birds." *Courtesy the* Pittsburgh Post-Gazette.

"He did not hesitate to say, 'I don't know,' frequently in reply to queries by his interviewers," according to the newspaper. Einstein was in Pittsburgh for a meeting of the American Association for the Advancement of Science. He remains best known for his theory of relativity—which concludes, among other things, that time depends on how fast you are moving—and for the famous formula "$E = mc^2$" (energy equals mass multiplied by the speed of light squared).

During his lecture at Carnegie Tech, now Carnegie Mellon University, Einstein filled chalkboards several times as he offered what he called a new and simplified proof for that equation. Howard W. Blakeslee, the Associated Press science editor, had the task of interpreting Einstein's December 28 talk for *Post-Gazette* readers. A native German speaker, Einstein delivered his Carnegie Tech lecture in English. The newspaper said it was the first time he had done a talk in the language of his new homeland.

"He got rid of the complicated electromagnetic fields with which this equivalence of mass [or weight] and energy have heretofore been proven," Blakeslee wrote in a next-day story. "He used instead the simple collision of two material particles to prove the same thing." The journalist described the talk as "his first important speech in the United States and his first important announcement in several years."

Einstein had left Germany for lectures in America shortly before Adolf Hitler came to power in January 1933. Upon returning to Europe, he renounced his German citizenship and spent several months in exile in Belgium and Great Britain. He returned to the United States for good in October 1933.

Einstein spoke in the Little Theater at Carnegie Tech, which seated about four hundred people and was filled "from back wall to stage."

"Einstein slipped in by the back door and behind the stage curtain began covering two blackboards with figures and mathematical symbols."

"As mathematical symbols, they were unusually simple," Blakeslee wrote. "[O]rdinary letters and numerals, except one which somewhat resembled a snake striking." That was likely the mathematical symbol for an integral. "The curtain rose with Einstein standing beside the two blackboards, his greying hair standing at all angles, a boyish grin on his face which set the audience of scientists to chuckling," Blakeslee wrote. Mass-energy equivalence had been an important concept in the early 1930s for investigating atomic nuclei, where, Blakeslee wrote, 99 percent of the mass and 99 percent of an atom's energy were locked away.

After his talk at Carnegie Tech, Einstein agreed to meet with about twenty newspaper reporters at the home of Pittsburgh merchant Nathaniel Spear. He declined to discuss nonscientific topics, and to scientific questions he often answered that "we need more observational data" or "it remains to be proved." On one topic, he was more assured. "The idea that man might some day utilize the atom's energy brought the only emphatic denial from the noted scientist yesterday," the *Post-Gazette* reported. Releasing usable energy would require striking the nucleus with other atomic particles, he told reporters. "It's like shooting birds in the dark in a country where there are only a few birds," Einstein said.

As World War II approached, Einstein changed his mind about those odds, and he lobbied President Franklin Roosevelt to launch research into building a nuclear weapon. On July 16, 1945—slightly more than ten years after Einstein made his Pittsburgh prediction—he was proved wrong with the successful test of an atomic bomb.

1940: Marian Anderson Fills Every Seat

All 3,700 seats in Pittsburgh's Syria Mosque were filled when contralto Marian Anderson sang there on January 9, 1940.

"Miss Anderson's voice has been the subject of comment for so long now that it seems almost pointless to enumerate its qualities," *Post-Gazette* critic Donald Steinfirst wrote in the next day's newspaper. "In the upper range the voice production is effortless and apparently limitless. The low register is a golden molten tone."

While he loved her voice, Steinfirst quibbled with her program choices. "Last night's list included three arias of Handel, where one might have

sufficed, five Schubert Lieder, The Card Scene from Bizet's 'Carmen,' a group of modern songs, and the long awaited spirituals." He approved of the Georges Bizet selection. "All the drama and pathos of the scene were faithfully transferred into sound, the lower register being particularly warm and vibrant here," Steinfirst wrote. For future recitals, however, he suggested reducing the number of Franz Schubert songs and substituting works by Johannes Brahms, Richard Strauss or Hugo Wolf.

Anderson was born in Philadelphia in 1897 to African American parents. Barred from attending a local conservatory because of her race, she studied privately. She found limited success in the United States in the late 1920s, but she was warmly received during recitals tours in Europe that started in 1930. She returned to the United States and successfully relaunched her performing career in 1935.

During her 1940 visit to Pittsburgh, she featured a half dozen spirituals in the second half of her Syria Mosque program. Those selections met with Steinfirst's enthusiastic approval. "It is perhaps the sincerity with which they are sung that most endears Miss Anderson's spiritual singing to her audiences," he wrote. "There is no attempt to dress up these simple songs, no folksy coyness, only an honest, straightforward presentation sung straight from the heart."

Anderson's recital in Pittsburgh came nine months after what was her most famous concert: an outdoor performance in front of the Lincoln Memorial on Easter Sunday, April 9, 1939. The unusual venue for her recital followed a controversial decision by the Daughters of the American Revolution. The national organization denied permission for her to perform before an integrated audience in Washington's Constitution Hall. Urged to action by President Franklin Roosevelt, First Lady Eleanor Roosevelt and other officials, Interior Secretary Harold Ickes approved the Lincoln Memorial as an alternative site.

The DAR took steps to make amends. The organization invited Anderson to perform on the stage of its historic hall in 1943, and she returned to perform three other concerts there.

1965: Casals, Cliburn Offer Double Thrills

Music lovers in Pittsburgh had opportunities to hear both a rising star and a master artist when Van Cliburn and Pablo Casals performed here during the same week in 1965.

Cliburn, thirty, was a piano soloist and conducted the Pittsburgh Symphony in a benefit concert for the musicians' pension fund on April 20. The audience of two thousand for his performance filled Syria Mosque in Oakland. *Post-Gazette* music critic Donald Steinfirst praised Cliburn's Pittsburgh debut as a conductor and soloist in Sergei Prokofiev's Third Piano Concerto. "The young artist seemed to have no difficulty in communicating his wishes to the orchestra," he wrote in a story that appeared on April 21. "[And] since the Pittsburgh Symphony is a particularly flexible instrument, it responded nobly and gave the conductor fine support."

Cliburn woke up internationally famous after he won the First International Tchaikovsky Piano Competition in Moscow in 1958. He went on to have a long career as a soloist and recording artist. Although he took periodic breaks from performing, he continued to play until shortly before his death in 2013 at age seventy-eight.

Casals, world renowned as a cellist, was eighty-eight when he came to Pittsburgh to conduct two programs of music by Bach, including all the Brandenburg Concertos. "It was a momentous and breath-taking evening of music making from the moment the diminutive, wiry conductor lifted his baton," Steinfirst wrote on April 23, the day after the first concert at Carnegie Music Hall in Oakland. Casals's orchestra for both programs comprised members of the Pittsburgh Symphony, joined by faculty and students from the music department at Carnegie Institute of Technology, now Carnegie Mellon University.

"Casals' direction must be seen as well as heard," the story said. "He was supposed to conduct from a seated position but the excitement of a phrase, the upsurge of a crescendo or the neat realization of a cadence brought him to his feet time and again. He sings a bit here and there, and he is not above stamping his foot to bring an errant musician into the strict tempi he employs."

Casals's concerts in Pittsburgh by no means marked the end of his long career. The cellist continued to give master classes and conduct until shortly before his death at ninety-six in 1973.

Chapter 3

FIGHTING FOR EQUALITY

1847: RESPECT FOR DOUGLASS, GARRISON

Abolitionist leader Frederick Douglass had reason to worry about the kind of reception he would receive in Pittsburgh in 1847. Born a slave around 1818 in Maryland, Douglass had tried several times to escape to the North, finally succeeding in 1838 with the help of a free black woman he later married. He achieved international renown with his autobiography, published in 1845. By the time he began a lecture tour two years later with William Lloyd Garrison, a white leader of the abolition movement, Douglass had become the human face for the campaign to end the South's "peculiar institution."

But not everyone in the North was a fan. When Douglass, twenty-nine, was leaving Philadelphia on the next leg of a speaking tour across Pennsylvania, he had been pulled out of a railway coach by an attacker who demanded he give up his seat. His white assailant turned out to be a Harrisburg lawyer. Garrison, forty-one, wrote in a letter home that the incident provided evidence of "that venomous pro-slavery spirit which pervades the public sentiment in proportion as you approach the borders of the slave States." Penn State University historian Ira V. Brown described Douglass's and Garrison's experiences across Pennsylvania in an article called "An Antislavery Journey" that appeared in the autumn 2000 issue of *Pennsylvania History*.

Things got worse for the speakers after they arrived by train in Harrisburg. When Garrison and Douglass attempted on August 7 to argue the case for an

When Frederick Douglass visited Pittsburgh in 1847, he and William Lloyd Garrison were greeted by a brass band. *Courtesy the* Pittsburgh Post-Gazette.

immediate end to slavery, protestors threw rotten eggs, firecrackers and stones into the Dauphin County Courthouse where the men had been addressing supporters. Two days later at Chambersburg, where the railroad line ended, the two abolitionists split up. Douglass's ticket let him go on ahead on a stagecoach ride that took him over the Allegheny Mountains to Pittsburgh. Douglass later told Garrison that he had been the subject of insults and "petty annoyances" during that leg of the trip. Inns would not serve him, and he had only a few crackers to nibble on during his two-day journey.

Things improved when Douglass arrived here on August 11. He was greeted at the stagecoach office by John B. Vashon, a successful black barber and businessman. When Vashon took Douglass to his home, they were met not by brickbats but by a friendly reception committee of black and white supporters and even a brass band. That night, Douglass and Garrison, who had arrived later that day, both spoke at a meeting in the city's Temperance Hall, which stood at the southeast corner of Smithfield Street and what is now Forbes Avenue.

Reporters for the city's major newspapers were impressed. George Vashon, the lawyer son of John, introduced Douglass, who was described as "the celebrated colored lecturer" in the August 12 edition of the *Pittsburgh Daily Gazette*. "Mr. D. acknowledged the friendship and courtesy extended to him," the *Gazette* reported. "After a few general remarks, [he] went into an argument to justify his conduct and declarations in reference to slavery in the United States." His "conduct and declarations" referred to the speeches he had made during a lecture tour in Great Britain and Ireland where he called for an immediate end to slavery or the dissolution of the United States.

The willingness of Douglass and Garrison to break up the Union worried the editor of the *Daily Pittsburgh Dispatch*, who, using the editorial writer's "we," described himself as "anti-slavery in all our feelings." "While we readily admit that they are both possessed of considerable merit as speakers, we are impelled to express our regret that they indulged in such embittered attacks upon the Union," the newspaper said on August 13.

The *Daily Morning Post* was the city's Democratic Party paper, and it was generally sympathetic to the South. While respectful in its coverage, the newspaper took issue both with Douglass's arguments and choice of words. The *Post* on August 12 referred to Douglass as "this distinguished colored man, who has traveled Great Britain and the Northern States, lecturing in defense of Anti-Slavery doctrines." Describing his speech at Temperance Hall, the newspaper said he was "a very eloquent speaker and exhibits intellectual greatness." The writer then went on to urge Douglass to "exercise a little more liberality towards those who do not come up to his idea of right in their opinions and conduct. The simple word 'slaveholder' would convey Mr. D's idea quite as well as 'man stealer,' 'thief' or 'plunderer.'"

Douglass and Garrison were the headliners at three local abolitionist meetings, including two outdoor sessions held in a park facing what is now Penn Avenue. "There was an immense crowd of white and black of both sexes and of all ages," the *Post* reported on August 13. "Excellent order prevailed, which we notice to the credit of the city."

"The address of Mr. Douglass was characterized by sarcasm, invective, simile and argument," the paper said. "He spoke boldly in favor of dissolution of the Union—this, in fact, was his theme. He denounced the federal Constitution and all the men now at the head of the government."

The *Gazette* provided the most extensive coverage of the abolitionists' visit, devoting more than a full column in its August 13 edition to the morning, afternoon and evening meetings. In his evening talk, Douglass "contrasted his bad treatment at home, and particularly while on his way to Pittsburgh," with the deference and respect he had been shown during his time in Europe, the *Gazette* reported. Douglass and Garrison had by far their greatest successes in Pennsylvania in their talks in Pittsburgh.

For their final stop in the Keystone State, the two men were joined in Beaver County by Martin Delany. Delany, then working as a physician and newspaper editor in Pittsburgh, would go on to become the highest-ranking black officer in the Union army during the Civil War. The three men and several other supporters traveled by steamboat to the town of Beaver and then continued on in a horse-drawn wagon to nearby New Brighton.

"The New Brighton town officials would not permit a meeting in the town square and, on inquiry, they found that no church was available," historian Benjamin Quarles wrote in his 1948 biography of Douglass. The only spot for a meeting was a loft above a feed store where bags of grain were stored. That location, according to biographer Henry Mayer, opened the way for Garrison to make an awful pun. Mice had nibbled at the bags of milled

grain stored above the speakers' platform, Mayer wrote in *All on Fire: William Lloyd Garrison and the Abolition of Slavery*. The "sprinkle of white dust reminded the editor…to make his talk 'a little more floury.'"

Pittsburgh can take pride in the welcome it gave to abolition leaders during their 1847 visit, according to University of Pittsburgh history professor Laurence Glasco. "Western Pennsylvania and Ohio were centers of antislavery activity," Glasco said in a 2014 interview. The abolition movement began in places like Boston, but it gained strength among whites in the Midwest. Farmers, workers and small businesspeople all saw it in their interest to oppose slavery, he said.

Glasco, an associate professor at the University of Pittsburgh, is an expert on the region's black history. "Abolition got tied up with the idea of 'free soil,' and rural populations saw slavery as something that would harm white people," he said. "They feared that slave owners would repeat the pattern in the South: buy up large tracts of the best land and run their plantations with slaves. They said, 'Gee, a white guy can't compete with that.'"

That economic argument was linked with a spiritual one, Glasco explained. As religious revivals swept through the region, more and more people came to regard slavery as a moral crime. In the years before the Civil War, Pittsburgh was only forty miles east of the border with slaveholding Virginia, now West Virginia. "Until runaway slaves could reach black neighborhoods in Pittsburgh, they had to count on friendly whites to shelter them," Glasco said. The homes and farms of white supporters became stops on what was known as the Underground Railroad. The advantage could be two-way. "Rural whites could take in runaways, have them do some chores, give them a little money and send them on their way," he added.

When Garrison and Douglass brought their abolition campaign to Pittsburgh, Garrison, the white antislavery activist, was seen as more radical than Douglass, a former slave. "Garrison was so fanatic that he gave speeches where he would tear up copies of the Constitution," Glasco said. "He feuded with antislavery people who just wanted to keep slavery from spreading. He wanted immediate emancipation."

For Garrison, it was literally true that some of his best friends were black. "A number of white abolitionists were against slavery, but they were not comfortable around blacks," Glasco said. "Garrison would break bread and enjoy the company of black people, accepting them as equals and brothers."

Douglass was more pragmatic and sought to build political alliances to support emancipation and civil rights, including the right to vote, for

African Americans. Douglass believed that African Americans were fully Americans. "His position was, 'We belong here, we are going to stay here and we will make this country live up to its ideals,'" Glasco said.

In contrast to Pittsburgh's Martin Delany, Douglass opposed colonization plans that would have relocated African Americans to Africa, Haiti or other territory outside the United States. "Douglass was a towering figure, and he brought the rest of the country's black population along with him," Glasco said. "As a result we've never had a tradition of black sedition or rebellion against the United States—despite some of the things black people endured."

1853: DEATH OF AN EARLY BLACK LEADER

By the time he turned sixty, John B. Vashon had found success in enough careers for a half dozen men. Vashon, born free in Virginia in 1792, was the son of a white slave owner named George Vashon and a family slave named Fanny. His eventful life was described in an online biography that is part of a 2008 multimedia presentation called "Free at Last?" created by the University of Pittsburgh's Robert Hill. Hill retired in 2013 as Pitt's vice-chancellor for public affairs.

Vashon served as a sailor aboard a U.S. Navy warship during the War of 1812. During that time, he was captured by the British and held as a prisoner of war for two years. Following his release, he returned to Virginia and married. In 1822, he moved his family to Carlisle, where he ran a saloon and livery stable. In 1829, the Vashons moved to the booming city of Pittsburgh. Here he found more success as a businessman, working as a barber and proprietor of a bathhouse. His bathhouse also served as a station for escaped slaves headed north on the Underground Railroad. The bathhouse and Vashon's home were on what is now Third Avenue near Market Street, where PPG Place stands today.

In the decades before the Civil War, Vashon was active in the region's abolition movement, holding the first meeting of the Pittsburgh Anti-Slavery Society in his house. The success of his businesses and real estate ventures made Vashon "one of the wealthiest Black men in Pittsburgh," according to the Pitt website. He spent some of his money on philanthropic causes, supporting abolitionist journals like William Lloyd Garrison's *The Liberator* and buying the freedom of one of his barber apprentices.

In an era when black residents were rarely mentioned in the city's newspapers, Vashon's unexpected passing on December 29, 1853, resulted in two stories in the *Daily Pittsburgh Gazette*. "Mr. T.B. Vashon, of this city, a well known and highly respected colored man, died suddenly from a stroke of apoplexy while waiting at the Passenger Depot of the Pennsylvania Railroad yesterday evening," the *Gazette* reported the next day. "He was about to embark for Philadelphia and was waiting for the departure of the train, when he was seen to fall," the story said. "A physician was immediately called, but to no purpose. The body of Mr. V. was immediately conveyed to his late residence on Third Street." He was sixty-one.

The December 31 edition of the *Gazette* had Vashon's correct initials in a story reprinted from the *Pittsburgh Evening Chronicle* that described his visit to the newspaper on the day of his passing. "He was in our office about an hour before his death, in high glee," the story said. "He had received a letter of introduction to a gentleman in Philadelphia, which would have admitted him to a participation in the 'Old Soldiers' convention about to be held there."

Despite his father's prominence, Vashon's son, George, a graduate of Oberlin College who trained as a lawyer, was turned down for admission to the Allegheny County Bar in 1847 and in 1868. It wasn't until 2010 that Nolan Atkinson, a Philadelphia attorney and a descendant of John and George Vashon, and Pittsburgh lawyer Wendell Freeland were able to persuade the Pennsylvania Supreme Court to posthumously admit George Vashon to the Pennsylvania Bar.

1855: Martin Delany, the "Go-To" Guy on Race

Martin Delany was the man Pittsburgh's leaders turned to when disputes broke out between blacks and whites in the decade before the Civil War.

In 1855, Delany was called in by Mayor Ferdinand E. Volz to negotiate the release of an African American woman seized from the dining room of a Pittsburgh hotel. The men who took her away included black staff members at the City Hotel. They believed that the unidentified woman was a slave being transported by her owner to Illinois. The story of Delany's role in that incident is one of several reports on black-led abolition efforts recorded during the 1850s in the pages of the *Pittsburgh Daily Gazette* and other local newspapers.

Journalist and physician Martin Delany is depicted in a life-size figure on permanent display at the Senator John Heinz History Center. Delany was one of the most important African American leaders in nineteenth-century Pittsburgh. *Courtesy Len Barcousky/* Pittsburgh Post-Gazette.

Delany was born a free black in what is now Charles Town, West Virginia, in 1812. He came to Pittsburgh as a young man and built up a reputation for intelligence, hard work and leadership. Working first as a barber when he arrived in Pittsburgh in 1831, he studied Greek, Latin and the Bible with a local minister and at what is now Washington & Jefferson College. He later apprenticed himself to a white doctor and eventually set up his own medical practice to serve the region's African American community.

"Three years after his arrival in Pittsburgh, Delany was both a founder and an officer in several organizations of young Negro men and women, all formed for the self-improvement of his race," Victor Ullman wrote in his 1971 biography of the black community leader.

Ullman said that one early sign of the local respect Delany had earned was his signature on a letter to the *Daily Pittsburgh Gazette* published on March 29, 1838. He and four other leaders of the black community, including Reverend Lewis Woodson and businessman John B. Vashon, denied as "wholly false" a

rumor that Pittsburgh's "colored citizens" had plans to storm the county jail and free an African American man sentenced to death for murder. In 1843, Delany began publishing *The Mystery*, a weekly newspaper that reported on the antislavery movement. His publication struggled, but a story in the *Pittsburgh Morning Chronicle* provides evidence of community support.

The city's African American residents celebrated every August 1—the date in 1834 when slavery was abolished in most of the British empire—for many years. The *Chronicle* reported on August 5, 1846, that the weather had been perfect for that year's commemoration, which raised money for Delany's newspaper.

"We paid a visit…and found collected together a large concourse of the better class of our colored people, and a pretty good sprinkling of whites," the story said. "We have not listened, for many a day, to a better address than that delivered by young [David] Peck…The amount of money taken in must have been large," the story concluded, "No doubt the 'Mystery' will be able to keep on its legs without difficulty hereafter."

Two years earlier, on November 28, 1844, the *Chronicle* had come to the defense of Delany when he was denied a seat while attempting to board a stagecoach in Columbus, Ohio. Delaney, "the talented editor of the 'Mystery' of this city…was ordered out of a stage…although he had paid his passage money and had a receipt for the same in his pocket." The writer then went on to offer what was a left-handed compliment at best: "Mr. Delany, though a colored man, is a gentleman of talent and ability, and is doing much to place his brethren on a higher elevation than they have heretofore stood in society, as respects education and morals."

Considering Delany's background, it was not surprising that Mayor Volz would turn to him to resolve the seizure of the black woman at the City Hotel. The March 6, 1855 "consultation" that followed the effort to "rescue" the black woman "was attended by a large number of colored people," according to a story that appeared on March 8 in the *Gazette*. "As far as we can learn, it was a meeting of an organization which has for its object the seizure of slaves passing through the city, and is probably what is known as 'the Underground Railroad Company.'"

The Underground Railroad was the name given to a network of antislavery activists. They identified and operated farms and safe houses where escaping slaves could find shelter and aid while they made their way farther north to Canada. The passage by Congress in 1850 of the Fugitive Slave Law had made it a federal crime to help escaping slaves or hinder efforts to capture them. The hefty punishment for conviction was six months in jail or a $1,000

fine, the equivalent of more than $27,000 in modern currency. The risk of imprisonment or fine doesn't seem to have deterred efforts by many blacks and whites in Pittsburgh to help those fleeing the South.

The City Hotel incident took place at breakfast, when a man named Slaymaker was dining with his family and a black female servant. "Mr. S. noticed that waiters were unusually abundant, as many as five or six being near him at once, but he suspected nothing," the newspaper reported. A group of African American men "entered the dining room from the kitchen door, and seized the black woman," the story said. "She screamed, cried out that she was free, that she was not a slave, that she was born in Pennsylvania, but without avail." Slaymaker told the newspaper someone struck him during the melee, possibly a black barber named Davis.

The City Hotel was at the corner of what is now Third Avenue and Smithfield Street. A black-owned barbershop was nearby on Third Avenue, and the woman was first kept in a basement there and then moved to an unknown location, according to the *Gazette*.

Slaymaker was advised to appeal immediately to Mayor Volz. "He also produced the necessary papers to prove that the woman was born in the State of Pennsylvania and was free," the story said. "It was then suggested that if these facts be made known and substantiated to some respectable colored citizen that there would be no difficulty in getting the woman back."

Volz turned to Delany. "Dr. Delaney repaired thither and on an examination of the documents declared himself satisfied that the woman was free." (As it sometimes was, Delany's last name was spelled with a second *e* in the *Gazette* report.) Delany, accompanied by a city policeman named Frost, walked from Market Square to a house on what is now Webster Avenue "in the upper part of the city." There they met with a dozen black men who looked through Slaymaker's documents with Delany. They then agreed to release the woman. "The party then started down and got the woman from a house somewhere near the intersection of Cherry alley with Strawberry alley," the story said. "Frost was not permitted to go to the house." Those streets now are called William Penn Place and Strawberry Way.

"The woman was then conducted back to the City Hotel and delivered into the charge of Mr. Slaymaker," the *Gazette* reported. "Dr. Delaney furnished Mr. S. with a certificate addressed to 'The Friends of Liberty' in which he… declared the woman as free." "Mr. S. is an anti-slavery man in sentiment," the story concluded. "He and his family leave for the west today."

Anonymous Pittsburgh "agents of the underground R.R. Co." also played a role in assuring that a group of ex-slaves freed by their late Virginia

master retained their liberty. "The Wind Blows from the South Today" was the headline on a story that appeared on June 20, 1855, in the *Gazette*. "On Monday we heard some of our colored population make use of the above phrase," the story said. The writer "learned that it meant that we had received an addition to our colored population."

After the death of their owner, his will required that his freed slaves were to be "sent to, and provided for, either in Penna. or Ohio," the story said. The group had been transported to Pittsburgh, and it was set to travel down the Ohio River on the steamship *Caledonia*. The fact that the ship's final destination was the Gulf of Mexico, deep in the slaveholding South, raised suspicions among the Underground Railroad supporters here.

"While [the former slaves were] here, the man who had them in charge refused to give them any satisfaction as to what disposition he was going to make of them," the story said. That created "the presumption that he might take them beyond the place designated in the will" and sell them back into bondage. Slaves in Texas and Louisiana were worth as much as $1,500, or more than $41,000 each in modern currency. "If an agent were disposed to be dishonest, he might avail himself of so favorable a chance," the reporter speculated.

"[T]he manumitted slaves were induced to leave the boat and their suspicious agent," the story said. The article described them as intelligent and well dressed. "One thing is certain. They had more sense than to trust themselves and their liberty to the uncertainty of a trip on a Western Steamboat bound for the South West."

1855: ABOLITIONIST MISTAKEN FOR SLAVE CATCHER

Henry Northup, the New Yorker who rescued Solomon Northup, a free black, from illegal bondage, found himself suspected of being a slave catcher himself when he visited Pittsburgh in 1855.

Reports in the *Daily Pittsburgh Gazette* and the *Daily Morning Post* that year laid out the tale of mistaken identity. The *Gazette*, which was sympathetic to the abolition movement, said the incident also provided evidence that "the mass of our citizens are sound on the slavery question." Solomon Northup was the author of *Twelve Years a Slave*, a book about his captivity that was made into a 2013 film of the same name.

Many members of Pittsburgh's African American community were on edge during the summer of 1855. The 1850 Fugitive Slave Law, which made

An illustration from the 1854 edition of *Twelve Years a Slave* shows Solomon Northup greeting lawyer Henry Northup, who will eventually take him back north. *Courtesy the* Pittsburgh Post-Gazette.

it a crime to assist blacks escaping from the South, was in full force, and all law enforcement officials were required to carry out its provisions. Citizens who violated it faced fines and jail. Pittsburgh, nevertheless, remained an important stop on the Underground Railroad. That was the name given to an antislavery network whose members identified and operated safe houses

where escaping slaves could find shelter and aid while they made their way north to Canada.

The *Gazette* was the city's Whig and Republican newspaper, and its editorial policy opposed slavery. The *Post*, on the other hand, was sympathetic to the South and its "peculiar institution." Not surprisingly, the *Post* relished retelling the tale of how Henry Northup was mistaken for a slave catcher when he arrived in Pittsburgh on July 15. His apparent mistake was to immediately ask for information on the whereabouts of the local U.S. marshal and other federal law enforcement officials. Making contact with federal authorities often was a first step in seeking their assistance in recovering what was considered stolen property: an escaped slave. "Several of the 'affiliated' [with the Underground Railroad] soon heard of the circumstance…and quickly sent word to their brethren in all parts of town that there was a negro-catcher in our midst," the story said. Black ministers, preaching that day, "even went to so far to announce the news from their pulpits, accompanied by the warning that if any fugitives were present, they should conceal themselves," the newspaper reported.

The *Post* took advantage of the story of Henry Northup's misidentification to print not once, but twice, what is considered the most derogatory term for African Americans.

The *Gazette* then picked up the story. Northup was staying at the Monongahela House, the city's finest hotel. That night after the out-of-towner had gone to bed, "a committee of gentlemen waited upon him to ascertain the truth of the reports and to take such action as might be deemed proper, provided they were true," the *Gazette* story said on July 17. There is a strong hint of menace in the newspaper's description of the nighttime call on Northup.

Even after "H.B. Northup," identified himself as the resident of Sandy Hill, New York, who rescued his former neighbor, Solomon Northup, from slavery in Louisiana, at least one of his interrogators remained unconvinced. The suspicious questioner asked whether Henry Northup "might have stolen the livery of a saint to serve the devil in," according to the *Gazette*. The next day, Northup went to the office of the clerk of U.S. District Court, where he talked with a reporter from the *Gazette* and was again questioned by Pittsburgh abolitionists. "He was waited on by two committees of white and colored persons at the United States Building, but his explanations were of course satisfactory," the newspaper said.

The *Gazette* story identifies Solomon Northup as "the hero of the book so extensively circulated, entitled 'Twelve Years a Slave.'" In the final pages

of his first-person story, Solomon Northup described how Henry Northup, a lawyer, arrived at the last Southern plantation where he had been enslaved after his kidnapping more than a decade earlier. "I seized my old acquaintance by both hands," Solomon Northup wrote. "I could not speak. I could not refrain from tears. 'Sol,' he said at length. 'I am glad to see you.'"

Although the two men were not related, they share the last name via a connection with Solomon Northup's father, Mintus. Before he was freed upon the death of his owner, Mintus Northup had been a slave owned by the Northup family and took their name. Henry Northup was a relative of that family.

Despite Henry Northup's critical role in proving that Solomon Northup was a free man, a character by that name doesn't appear in the movie version of *Twelve Years a Slave*. In the Academy Award–winning film, a Saratoga, New York merchant named Parker comes to Louisiana and provides the written evidence of Solomon Northup's legal status as a free man.

While the *Post* concluded that Underground Railroad supporters should follow the adage "look before you leap," the *Gazette* drew another lesson from the incident with Henry Northup. Winking at abolitionist activities that were clearly illegal under the Fugitive Slave Law, the *Gazette* concluded that city residents, black and white, were following a higher commandment in obstructing slave catchers. "The prompt action taken by our anti-slavery friends shows that the mass of our citizens are sound on the slavery question," the story concluded. They "are fully resolved that no fugitive slave shall be taken from this city without an effort to resist it."

1865: *GAZETTE* BACKS FULL CIVIL RIGHTS

Black people had proved their courage both in combat and behind Confederate lines, the *Daily Pittsburgh Gazette* said in 1865. In return, they were due not just emancipation but aid and civil rights, the newspaper's owners argued.

It was a radical position for Josiah King, E.H. Irish and Robert Ashworth to take during the last months of the Civil War. The three men, operating as the Gazette Publishing Association, had acquired the newspaper in 1864. "Are people whose heroism has been attested on many battle fields and still better attested in acts of perilous kindness to dying prisoners of the Union, to be still kept down as a debased, disfranchised caste?" the newspaper

asked on March 29, 1865. "We hold that it is impossible to found firm and enduring institutions upon an uneven foundation—that an upper and lower caste are as dangerous to a free state as Liberty and Slavery."

The newspaper took that position while the issue of forbidding slavery had still not been formally decided. While Congress had approved the slavery-abolishing Thirteenth Amendment to the Constitution in January 1865, the measure still needed to be approved by two-thirds of the state legislatures. Pennsylvania's House and Senate had ratified the amendment on February 3, but it wasn't until December 1865 that the required two-thirds majority of state houses was reached. The *Gazette*'s civil rights editorial was not free of nineteenth-century prejudices. Blacks were "ignorant and illiterate, through no fault of theirs," possessing "dark minds." As people with dark skins, they carried the biblical "badge of degradation."

Nevertheless, the newspaper argued for schools, teachers and "all the rights and privileges of American citizens" for the nation's African Americans. Their military service in segregated units and their help to escaping and wounded Union soldiers throughout the South had made them "thoroughly tested patriots" and the "best and truest friends."

As the *Gazette* anticipated, the legal abolition of slavery wouldn't bring with it civil rights for African Americans. The Fourteenth Amendment, which granted citizenship to "all persons born or naturalized in the United States," was ratified in July 1868. While voting rights were promised in the Fifteenth Amendment, which was ratified in March 1870, poll taxes and unfair literacy tests kept most blacks in the South from the polls for almost a century.

1919: Black Veterans Get Heroes' Welcome

Black soldiers and officers from the 351st Field Artillery were the first large group of veterans to return to Pittsburgh from France after World War I. Their arrival on March 7, 1919, produced banner headlines in local newspapers and coverage by one of the city's star reporters.

"No wonder the Germans quit," pioneering woman journalist Gertrude Gordon wrote in that evening's edition of the *Pittsburg Press*. "Great Scott! Just look at them," she wrote, quoting an anonymous member of the city's reception committee. "They are wonderful looking. In the best of condition; hearty, brimming over with good health and joy to be back; proud of what

they have done; proud that their city greeted them so splendidly." Gordon was one of the first female reporters in Pittsburgh to get a regular byline. She is still remembered each year when the Women's Press Club of Pittsburgh presents scholarships named in her honor.

The anonymous reporter for the *Gazette Times* on March 8 also took note of how "hale, hearty and happy" were the "200 Negro heroes from Mars playground." The Mars reference was to the Roman god of war. "Patriotic Pittsburgh, mobilizing all its classes, colors and creeds, noisily greeted the triumphant entry…of the Three Hundred and Fifty-first Field Artillery," the story said. "Pittsburgh had waited long for the time when it could proudly welcome back in a body some of its brave boys." Although commanded by a white colonel, the 351st Field Artillery was a black regiment with mostly African American officers. The U.S. Army was strictly segregated by race and remained so until after World War II. The War Department had created the 351st under pressure led by black leaders from Pittsburgh after local soldiers had complained about discriminatory treatment.

The soldiers had arrived the morning of March 7 at Pittsburgh's Pennsylvania Station on Liberty Avenue. Local leaders on hand to greet them included Pittsburgh mayor Edward Babcock. "Mayor Babcock was the recipient of two gifts from the returning soldiers," Gordon wrote. "One gave him a German spiked helmet…while another gave him a German rifle, captured by an infantryman in a hand-to-hand battle."

After the men were served breakfast at the station, they formed ranks for a parade down Liberty Avenue to Fifth Avenue and then to the recently completed City-County Building on Grant Street. "One of the happiest men today was W.M. Richmond, of 7342 Monticello St., whose three sons, Charles, William and Arthur, came home today," Gordon wrote. Another returning serviceman was Sam Fairfax, who lived in the city's West End. He had taken part in his unit's twenty-seven-hour shelling of the German-held city of Metz. "I wouldn't take two million dollars for my experience over there," Fairfax said. Long a part of France, Metz was lost to the German Reich in the Franco-Prussian War of 1871 and reclaimed after World War I.

The stories and photos that appeared in the *Press* on March 7 and in the *Gazette Times* on March 8 emphasized the color-blindness of the celebration for the returning soldiers. The listing of some of the units taking part in the parade makes clear that Pittsburgh, like most of early twentieth-century America, was a city divided by race. Evidence of those two worlds is illustrated in the names of many of the groups and organizations participating in the multi-division parade. They included the Colored

Frank Bingaman took this front-page picture of Private John E. Brown of Thornburg greeting his sweetheart Lucinda Brown (no relation). Brown was a soldier in the segregated 351st Field Artillery when it marched through downtown on March 7, 1919, following service in France. *Courtesy the Carnegie Library of Pittsburgh.*

Home Guards, Colored Boy Scouts, Colored Knights Templar, Negro Knights of Pythias, Colored Elks and Colored Ladies of the GAR, the women's auxiliary of an organization for Civil War veterans.

While downtown crowds had been enthusiastic, those cheers "seemed as nothing" compared to the reception the black soldiers "received from the people of their own race in the Hill district," the reporter for the *Gazette*

Times wrote. The celebration for members of the 351st and their families concluded with a military ball at Duquesne Gardens in Oakland. That event gave "6,000 members of their own race an opportunity to take the returned heroes to their hearts," the *Gazette Times* story said.

1963: NEW CIVIL RIGHTS ADVOCATES EMERGE

Large demonstrations were the key to getting more employment in more industries for Pittsburgh's black residents, according to National Association for the Advancement of Colored People president Byrd R. Brown. Brown and Wendell Freeland, president of the Urban League of Pittsburgh, were featured speakers on October 8, 1963, at a downtown meeting of the Allegheny County Council on Civil Rights. The two men were among a new generation of black leaders who played major roles locally during a landmark year in the struggle for equal rights.

"Brown promised his audience that 'you will see more demonstrations and more picketing than you have ever seen before,'" *Post-Gazette* reporter Alvin Rosensweet wrote in a story that appeared on October 9. Brown said that he was disappointed that he had seen few of the people in his audience on picket lines during anti-discrimination events organized by the United Negro Protest Committee. That committee was an offshoot of the Pittsburgh branch of the NAACP. "I don't want to mince words on this," Brown told his audience at the Downtown YWCA. "You cannot deny that the direct approach is correct. We have gotten more jobs in the last two months by demonstrations than we got in the last two years without demonstrations."

Among the companies that changed their hiring practices following those 1963 street protests was Duquesne Light. Speaking to a *Post-Gazette* reporter in 2001, Harvey Adams, another former NAACP president, said the utility "became a good corporate neighbor, hiring blacks throughout its ranks."

Brown, a graduate of Yale Law School, was elected president of the local chapter of the NAACP in 1958 and held that post until 1971. In 1989, he ran unsuccessfully for Pittsburgh mayor. He died in 2001 at age seventy-one.

In his 1963 remarks, the Urban League's Freeland called for "action, not slogans, to compensate for the deprivations of the past." He said his organization had begun to offer "retraining courses and a 'census of skills' to help Negroes become qualified for employment." The Urban League also

would go "into the Negro community to determine the skills of individuals, such as electricians, plumbers and other craftsmen, so they can be placed in jobs as employment opportunities open up."

Freeland was a Baltimore native who served as a bombardier with the Tuskegee Airmen during World War II. He graduated from Howard University and the University of Maryland School of Law. He was back in the news in 2010 when he persuaded the Pennsylvania Supreme Court to posthumously admit George Vashon, a nineteenth-century African American lawyer from Pittsburgh, to the Pennsylvania Bar. Vashon's application had been turned down by the Allegheny County Bar in 1847 and in 1868. Freeland and Nolan Atkinson, a Philadelphia attorney and Vashon's great-grandson, petitioned the high court on behalf of the lawyer's descendants. Freeland continued to practice law until shortly before his death in 2014 at age eighty-eight.

Earlier in that watershed year, the nation marked the 100th anniversary of the Battle of Gettysburg. The likelihood of civil rights protests resulted in an extra three hundred state troopers being posted to Gettysburg for the commemoration ceremonies, the *Pittsburgh Post-Gazette* reported on July 1, 1963. State police officers were present both for crowd control "and to cope as gently as possible with any possible racial demonstrations," said the story by the Associated Press. "There are rumors, though they are not solid, that Negroes may demonstrate for 'freedom now' as they have done in many communities in North and South."

Stories in the *Pittsburgh Press* and *Post-Gazette* over the next few days made no mention of civil rights protests at Gettysburg during the parades, commemorations and battle reenactments. The struggle for equality, however, was on the minds of several prominent speakers. About three thousand people stood in the sun for a wreath-laying ceremony at the military park's Eternal Light Peace Memorial on July 1. That crowd was much smaller than officials had expected. Afternoon temperatures pushing one hundred degrees likely kept down the numbers.

Governors from twenty-nine states attended, including Pennsylvania's William Scranton and Alabama's George Wallace. The heat turned the ceremony informal "as perspiring governors and other dignitaries on the monument stage shed their coats," the *Post-Gazette* reported on July 2. Governor Scranton, the main speaker at the Peace Memorial service, talked about business left over "from the war between brothers." That work included "the task of driving prejudice out of the human heart as least as readily as we are learning to drive men into outer space."

The new birth of freedom that Abraham Lincoln promised in his Gettysburg Address had been delayed, Scranton told the crowd. "Now the new freedom begins to move again, this time into stormy adolescence," he said. "In the South, in the North, in the West—in every section of the nation men are called to look into their own hearts."

Many chief executives from other states attended similar rededication events at Gettysburg battlefield monuments to their soldiers. At one of those events, New Jersey governor Richard J. Hughes made the day's "strongest plea for full civil rights for all Negroes," the *Post-Gazette* reported. "It is our shame at this moment that the full benefits of freedom are not in the possession of all Americans, a full century after the war which was fought to save America's soul," Governor Hughes said. He also noted that inequality in America represented a "clear and present danger" to the nation's future, according to a *Pittsburgh Press* story on the same event. "The Civil War was not fought to preserve the Union 'lily white' or 'Jim Crow,'" the governor told the crowd. "It was fought for liberty and justice for all."

As the United States marked the anniversary of the bloodiest battle of the Civil War, the nation continued that summer to struggle with its failure to assure equal treatment under the law to African Americans.

President John F. Kennedy had introduced civil rights legislation on June 19, but his bill was believed to have little chance of passage. A week earlier, Alabama governor Wallace had stood in a campus doorway in an effort to stop enrollment of two black students at the state's public university.

In Mississippi, NAACP leader Medgar Evers was gunned down on June 12 in his driveway. Eight weeks after the Gettysburg events, Reverend Martin Luther King would lead a "March on Washington" to push for voting rights, equal education opportunities and an end to housing discrimination. It was at that March on Washington for Jobs and Freedom that King delivered his "I Have a Dream" speech.

Despite those national and local efforts, it wasn't until 1964 that a federal civil rights law was passed by Congress.

1994: Donald C. Jefferson Broke Barriers

Donald C. Jefferson was not afraid to stand up for what was right in an era when an "uppity" black man risked a beating, jailing or even hanging. Jefferson, who died in Pittsburgh in 1994 at age ninety-two, was among a

small group of African Americans to be commissioned as U.S. Army officers during World War I. He was one of about 1,200 African Americans who earned an officer's commission during the "Great War." While that number was much larger than in previous conflicts, military historian Michael L. Lanning wrote that it represented a tiny fraction of the 368,000 black men who served during the war.

Jefferson was a twenty-two-year-old pharmacy student at the University of Pittsburgh when he was drafted in 1917. He soon discovered that African American soldiers, for the most part, would be assigned to support and service tasks. Black soldiers with high school and even college educations were given little opportunity to become officers, Lanning wrote in his 1997 book, *The African-American Soldier.* One reason was the refusal by white soldiers to take orders from black officers.

In a 1988 interview with the *Post-Gazette*'s Carmen J. Lee, Jefferson described how he and eight other Pittsburgh men stationed at Fort Lee, Virginia, wrote secretly in October 1917 about the army's restrictive policies. They sent individual letters describing the conditions to influential black leaders back home. The recipients included Robert L. Vann, publisher of the *Pittsburgh Courier*, an African American newspaper with national readership, and Reverend Shelton Hale Bishop, rector of the city's Holy Cross Episcopal Church. After Reverend Bishop visited Fort Lee, he and other local black leaders renewed their protests to Washington, D.C., about unequal treatment and reduced opportunities for African American soldiers.

Their lobbying produced results. On November 15, 1917, fifteen black soldiers, including Jefferson and the rest of the Pittsburgh men, were transferred to Camp Meade, Maryland, for artillery training. Many of those men and several hundred African American soldiers recruited in Pittsburgh ultimately were assigned to the new black unit, the 351st Field Artillery. "This regiment owes its birth to a sustained protest on the part of Negroes of this city and vicinity," a story in the *Pittsburgh Gazette Times* said on March 8, 1919.

Most of the unit left Camp Meade in June 1918 for France and saw action on the Western Front in the final months of the war. "After several weeks of strenuous drilling, the regiment went into action…southwest of Metz," the *Gazette Times* story said. The newspaper report went on to list a dozen locations where the 351st provided artillery support for infantry attacks. The story describing the regiment's formation and battle history had appeared the day after a March 7 welcome-home parade for the Pittsburgh soldiers. The line of marchers went through downtown Pittsburgh and the Hill District.

Right: Donald C. Jefferson was ninety-two when he donned his World War I uniform again for a photograph in 1988. It still fit. Jefferson died in 1994 at age ninety-eight. *Courtesy Tony Tye/* Pittsburgh Post-Gazette.

Below: Lieutenant Donald C. Jefferson, *at left*, was twenty-four when he and his fellow officers in the 351st Field Artillery led the parade of black soldiers through Pittsburgh on March 7, 1919. *Second from the left to right*: Lieutenant William J. Curtis, Lieutenant John Carter Robinson, Sergeant William Stewart and the unit chaplain, Reverend E.O. Woolfolk. *Courtesy the* Pittsburgh Post-Gazette.

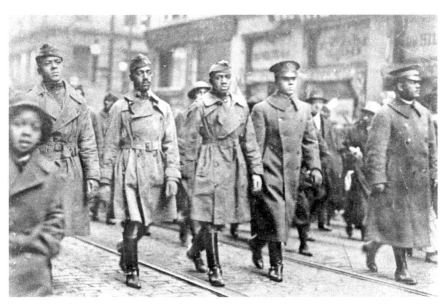

That same day's edition of the paper included a sidebar story about and a photo of Jefferson. He was described as "the officer in charge of the detachment of Negro artillerists that was given a royal welcome here yesterday." The story also included information on Jefferson's athletic and academic careers at Pittsburgh's Fifth Avenue High School. A star athlete, Jefferson was the first black member of Pittsburgh's All-Scholastic Football Team.

Jefferson and several other black officers had received their artillery training at Camp Zachery Taylor in Louisville, Kentucky. The men later were traveling together by train to a South Carolina army camp when they took their stand against Jim Crow segregation laws in the South, declining to sit in a "colored" passenger car. As Jefferson told the story in 1988, the black officers found the conductor and requested more comfortable Pullman seats. "They reached a packed car reserved for white passengers, and an attendant told the young men that if they did not leave, he would summon the law." Jefferson responded, "We stood our ground and said, we are the law." "Silence fell over the crowded train car, and soon Jefferson and his friends were escorted to their Pullman seats," Lee wrote.

Jefferson and his fellow officers who had trained at Camp Taylor arrived in France several months after most of their regiment. Second Lieutenant Jefferson then was among a small group of soldiers assigned to a French artillery school for advanced education. He still was completing that course when the war ended with an armistice on November 11, 1918.

Jefferson had worked for a few years after high school to earn money for college and had been a freshman when he was drafted, according to his 1994 Post-Gazette obituary. After the war ended, he returned to Pitt and earned his pharmacy degree. From 1923 to 1967, he operated the Lincoln Drug Company in the city's East Liberty neighborhood. It was described as the first black-owned business in that neighborhood. He was active for decades in both African American and broader business and political organizations. He was the founder of the Twelfth Ward Citizens League and the Business and Professional Association, which encouraged the growth of black businesses. He was vice-chairman of the Allegheny County Redevelopment Authority board and held the same office for the county Housing Authority.

In 1988, he was honored by the Pennsylvania House of Representatives. The citation was co-sponsored by then Speaker of the House K. Leroy Irvis and veteran state representative Joseph Preston. It took notice of Jefferson's war service and role in the protests that helped lead to more opportunities for officer training and the creation of the 351st Field Artillery. That state

recognition came a few months after Jefferson sat down with *Post-Gazette*'s Carmen J. Lee to talk about his wartime experiences. During the interview, he put on the World War I uniform he had worn in Europe and in the 1919 "welcome home" parade in Pittsburgh. Sixty-nine years later, it still fit.

Chapter 4

REMEMBERING THOSE WHO SACRIFICED

1818: JOSHUA BARNEY WAS A HERO IN TWO WARS

Joshua Barney, a naval hero during both the American Revolution and the War of 1812, "died among strangers…far from the sea he loved," biographer Louis A. Norton wrote in 2000. Barney became ill near Pittsburgh while traveling by flatboat with family members down the Ohio River to his new home in Kentucky. He died and was buried here in 1818.

The Maryland native, however, had not been forgotten by residents of Pittsburgh. Thirty years after his death, his body was moved to a prominent spot in the newly opened Allegheny Cemetery in Lawrenceville. The location of his grave is called Mount Barney. In 1880, the cemetery association erected a monument over his remains and those of Lieutenant James Lawrence Parker, a heroic sailor from the Mexican-American War.

Commodore Barney received additional posthumous honors on August 4, 2012, when a new memorial plaque was dedicated during ceremonies attended by several of his descendants. That year marked the 200th anniversary of the start of the War of 1812. "He was a very complex man," Caroline Bradford, eighty-seven, said of her ancestor in 2012. "He was very persistent in following what he thought was right," she said. "He was very patriotic and also somewhat arrogant. I think we need to overlook that." Bradford, a retired nurse, lives in Mechanicsville, Maryland, not far from where her ancestor fought some of his battles. She is Barney's direct descendant, eight generations removed.

Commodore Joshua Barney is among an exclusive group whose members won fame for their military service in both the American Revolution and the War of 1812. Barney, a Baltimore native, died in Pittsburgh and is buried at Allegheny Cemetery. *Courtesy Bill Wade/ Pittsburgh Post-Gazette.*

The 2012 event at the cemetery resulted from cooperation among several Maryland and local organizations that seek to honor the memories of men and women involved with the founding and defense of the United States.

Joshua Barney, born in 1759, is in a very small group of people who won renown for military service in both the American Revolution and the War of 1812, according to Lou Raborg, of the Maryland Society of the Sons of the American Revolution. Raborg has his own family connection to Barney. His direct ancestors, the father-and-son team of coppersmiths Christopher Raborg Sr. and Christopher Raborg Jr., provided copper, brass and tin goods to privateers, including Barney, from their shop on Baltimore's Water Street. Their business journal for the years 1783 to 1811 includes the sea captain's signature. "My ancestors knew and did business with Barney," Raborg said.

Privateers were sort of legal pirates, private individuals authorized by their governments to disrupt trade and capture enemy ships. Profits for the crews and their investors came from the sale of the ships' cargoes.

The ten- by twenty-four-inch marker placed next to Barney's existing monument was provided by the Colonel John Eager Howard Chapter of the Maryland Society of the Sons of the American Revolution. John Eager

Howard, a contemporary of Barney, was a Revolutionary War soldier who later served as governor of and senator from Maryland. Each year the organization selects a different project to memorialize a Revolutionary War–era patriot.

Joshua Barney first went to sea in 1771 at age twelve. By 1775, he was second in command of a merchant ship captained by his brother-in-law during an Atlantic crossing. After his brother-in-law died during the voyage, Barney took over and successfully sailed into the port of Nice. When customs officials attempted to cheat the young captain and his crew, family lore reports that Barney crossed the Alps and successfully appealed that unfair decision to a French trade minister in Paris, said Bradford, his descendant. "He was always willing to fight for what he thought was right—even at that young age that was a dominant feature of his personality," she said.

He joined the Continental navy in 1776 and served on several warships. Taken prisoner several times, he was exchanged or escaped. His most famous action came late in the war when as captain of the warship *Hyder Ally*, he and his crew captured the better-armed HMS *General Monk*. After the American Revolution, he joined the French navy.

At the start of the War of 1812, he first harassed British shipping as a privateer and then rejoined the U.S. Navy. In the summer of 1814, he was involved in battles on both land and sea as part of an ultimately unsuccessful defense of Washington from a British attack. Commanding a Chesapeake Bay flotilla, he delayed the enemy advance, but finally he was ordered to scuttle his ships to prevent their capture. A few days later, Barney commanded several hundred marines at the Battle of Bladensburg, Maryland. That engagement, on August 24 just outside Washington, is often referred to as the "Bladensburg Races" because many of the American troops fled in panic. Barney's marines, however, continued to fight until their leader was shot in the thigh and captured. The ball was embedded so deep that it could not be removed and his wound never healed.

Barney married twice and had several children with each wife. Bradford; her sister, Mary Ann Stockstill; and many cousins are descended from Joshua's son, William Henry Barney. Following the death of Joshua Barney in Pittsburgh, his widow, Harriet, and their three children continued on to Kentucky. Bradford said that her branch of the family knows nothing more about what happened to them.

The 2012 dedication ceremony for the Barney memorial stone drew many people unrelated to the war hero. Navy veteran Fred Johnston said that it is important to remember American history and the people who made it. That

was the reason he and his daughter, Rebekah, drove from their home in Shaler to Allegheny Cemetery.

Barney's eighth-generation descendant Mary Jane Stockstill described him as "a faithful and obedient servant to our country. This native Baltimorean most significantly sought to secure and maintain peace on our home shores as commander in defense of the Chesapeake Bay area during the War of 1812," she said.

"His fortitude gained time for Baltimore to prepare its defenses to fight off a British attack," said Christos Christou Jr., Maryland state president of the War of 1812 Society.

Speakers at the memorial dedication also emphasized the continuing debt that Americans owe to all members of the armed services. "As we honor soldiers of the past, we also remember soldiers of today and what they are sacrificing so we can enjoy our freedoms," said Sharon Goetz, Maryland state registrar for the DAR.

Fife player David Embrey and drummer Robert Ayres provided period music for the ceremonies. They were part of a Maryland-based color guard wearing uniforms from the Revolution and the War of 1812 that would have looked familiar to Barney. The reenactors fired three volleys over his grave just before bugler Michael Foster played taps to close the thirty-minute program.

1918: Honoring Veterans of the Great War

Robert T. Messner stood next to the memorial in Braddock honoring the men from the borough who fought in the "War to End All Wars." More than eight hundred names are inscribed on the base of the bronze monument, starting with Harry Abt and ending with Josef Zylinski. A separate plaque lists the names of the twenty-eight men from Braddock who died during World War I.

Messner, who is director of the nearby Braddock's Battlefield History Center, said that it was important to honor the memory of the veterans who served during all of the nation's conflicts. "If you don't know where you've been, it is difficult to know where you want to go," he said during a 2014 interview. "Memorials like these help us to remember who we are and the price that has been paid by the people who went before."

The Braddock memorial, dedicated in 1922, was designed by sculptor Frank Vittor. The bronze statue shows a winged goddess holding symbols of battle and victory. It is one of dozens of monuments, brass plaques

The Braddock memorial, dedicated in 1922, was designed by sculptor Frank Vittor. The bronze statue stands outside the community's Carnegie Library. It shows a winged goddess holding symbols of battle and victory. On its base are inscribed the names of eight hundred men from the borough who served during World War I. *Courtesy Len Barcousky/*Pittsburgh Post-Gazette.

and markers erected across southwestern Pennsylvania in the years after World War I to honor the men and women who fought in it.

"When the 'Great War' memorials were being put up, people believed that it had been the war to end all wars," said Andrew Masich. He is president and CEO of the Heinz History Center in the Strip District. "The use of airplanes, poison gas and high explosives had taken war to a new level of horror," he said. "When they dedicated these monuments, people believed they would be the last war memorials."

The nation's earlier wars had not lacked for commemorative monuments, according to Michael Kraus, curator and staff historian at Soldiers & Sailors Memorial Hall and Museum in Pittsburgh's Oakland neighborhood. What became known as World War I began while the nation was marking the fiftieth anniversary of the War Between the States.

"Memorializing of the Civil War was at its peak," Kraus said in a 2014 interview. But there was a difference in the kinds of memorials being erected to honor participants in the two conflicts. While many Civil War monuments honored generals and top commanders, World War I memorials were more likely to feature ordinary soldiers, he said.

The best known of the local "common man" sculptures may be the *Doughboy* in Pittsburgh's Lawrenceville neighborhood. The bronze statue at Butler Street and Penn Avenue was dedicated on Decoration Day—now known as Memorial Day—in 1921. "It is an amazing piece of sculpture," Kraus said of the work by sculptor Allen Newman. The subject "looks like he just finished a battle," he said. Resting most of his weight on one leg in a pose described as *contrapposto*, the soldier has slung his bayonet-topped rifle over his shoulder. He wears his tin helmet at an angle.

Italian American sculptor Giuseppe Moretti created a much more heroic-looking figure for his ten-foot-tall Soldiers Memorial in Bellevue's Bayne Park. Bellevue abuts Pittsburgh to the northwest. Moretti's statue has stood since 1921 at North Balph and Teece Avenues. It shows a bare-chested young man leaving his plow and anvil behind as he strides forward. In his right hand, he holds up a winged figure representing victory.

Like many of the local community monuments, it lists the names of everyone from the borough who served during the war. The plaques include those who volunteered for the YMCA-sponsored welfare services provided to U.S. soldiers in Europe. Among the names of the fourteen Bellevue residents who "gave the last full measure of devotion" is that of Alice Luella Thompson. According to a history of Bayne Park, Thompson was a nurse who died while in service.

The names of two men from the Pittsburgh suburb of Dormont are remembered at the community's Veterans of Foreign Wars post. After Dormont residents George McCormick and F.H. Dormon were killed in France in 1918, the local VFW post was named for them. In 2009, the community's World War I memorial was relocated to a spot next to the VFW on busy West Liberty Avenue. John Meighen, the quartermaster (or treasurer) of McCormick-Dormon Post No. 694, was part of the veterans group that undertook to find a new home for the memorial.

Originally dedicated in 1930, the memorial stood for many years on Memorial Drive in Dormont Park. "Nobody saw it where it was," Meighen said of the previous location. "Half the people in town didn't even know it was there." The new location gives the memorial deserved prominence and makes it part of a larger tribute to veterans, he said.

The granite monument is inscribed with these words: "Dedicated to the memory of the boys from Dormont, Pennsylvania, who made the supreme sacrifice fighting for the cause of liberty in the World War." When it was relocated during Dormont's centennial celebration, it was placed in front of a new memorial wall that dedicated the site "to the veterans of all wars."

Something similar has happened in Neville, the township that occupies all of Neville Island downriver from Pittsburgh. The bronze plaque inscribed with the "Roll of Honor of the young men who answered the call of their country in the Great War" was erected in 1920 in front of the township building. It was moved to its current location in Memorial Park in 1983. The original plaque has been joined over the decades by new monuments honoring the men and women who served in more recent wars.

"These kind of memorials are so important to veterans and their families," Dorothy Antonelli said. "They show that their country and their community have recognized their service." Antonelli is president of Neville Green, a nonprofit community-betterment organization.

In nearby Coraopolis, the borough's *Charging Doughboy* statue has been on the move since it was dedicated in 1920. "Everybody in town donated money toward the statue," Thomas M. Buchman said. He is a member of the borough's historical society. The bronze memorial, cast by the V.C. Getty Company on Pittsburgh's North Side, cost about $3,400. That number is equal to about $39,500 in today's currency, based on changes in the consumer price index.

The statue was dedicated just after Armistice Day 1920 and stood for many years in front of the local high school on State Avenue. When that building was closed, the memorial was moved a few blocks to the community

library at State Avenue and School Street. Several years ago, the doughboy was relocated to Fifth Avenue and Mulberry Street and now stands in front of the VFW's Keith-Holmes Post No. 402.

The Mount Pleasant doughboy statue in Westmoreland County is cared for by members of the local VFW and American Legion posts with help from the borough. The thirty-five-foot-tall World War I memorial features a soldier standing atop a pillar. It was erected in the center of town at the intersection of Main and Diamond Streets. "Every time you come through Mount Pleasant, you have to go around the Doughboy," Mayor Jerry Lucia said. "It is a symbol of the community's love for veterans."

Nearby in Veterans Park is another monument to veterans that includes a twenty-first-century "digital wall." The giant computer screen is linked to a searchable data base that includes names, photographs and service information about many of those who served in the armed forces. "Mount Pleasant always has been a big supporter of veterans," borough manager Jeff Landy said.

While U.S. participation in World War I lasted only about eighteen months—April 1917 to November 1918—it was a conflict that called for service and sacrifice from both military personnel and civilians, Elizabeth Williams-Hermann said. The archivist at La Roche College, Williams-Hermann is the author of *Pittsburgh in World War I: Arsenal of the Allies*. "Families planted victory gardens; women worked in factories," she said. "It was everybody's war."

1941: RECALLING THE "DAY OF INFAMY"

William Miller, age fifteen, was at home in Wilkinsburg, listening to the radio after church on the afternoon of December 7, 1941. The program was interrupted by a news bulletin reporting a Japanese attack on U.S. forces 4,700 miles and five time zones away at Pearl Harbor. The location was not a familiar one to him. "I knew it was somewhere in Hawaii," he recalled during a 2014 interview. As a result of the Japanese attack and the decision by Adolf Hitler four days later to declare war on the United States, Miller found himself two and a half years later landing troops on Omaha Beach in Normandy.

Miller, eighty-eight, was living in Apollo, a borough about thirty miles northeast of Pittsburgh, when he was interviewed. He is one of a shrinking

Frank Regina in 2014 was one of the last—if not the last—Pearl Harbor survivors left in the Pittsburgh area. *Courtesy Julia Rendleman/*Pittsburgh Post-Gazette.

pool of southwestern Pennsylvania residents who have firsthand memories of what President Franklin Delano Roosevelt called "a date which will live in infamy."

Frank Regina, a North Braddock native, is part of an even smaller group. Regina, who joined the U.S. Navy in 1940, was one of the people under attack that day. His ship, the USS *Utah*, was sunk by Japanese torpedoes, and he and more than 450 fellow crew members had to swim for their lives. "We lost 58 men that morning," Regina, ninety-two, said during an interview seventy-three years after the attack. He and his wife, Peggy, eighty-five, reside at Beatty Pointe Village, an independent-living retirement community in Monroeville. His shipmates from the *Utah* were among the 2,400 sailors, soldiers and marines and 68 civilians who died at Pearl Harbor. He was nineteen on the day of the attack.

Like Miller, George Trent, then a freshman at Ohio's Wittenberg University, wasn't entirely sure where Pearl Harbor was. He and his fraternity brothers had a radio playing that day while they hit the books. It was shortly after 1:00 p.m. when they heard the first bulletins about the attack. "We didn't do much studying the rest of the afternoon," he recalled.

While poor eyesight derailed his plans to join the U.S. Navy, in 1942 Trent enlisted in the U.S. Army Air Forces at Wright Patterson Field. He qualified for the Army Specialized Training Program—a military program to produce junior officers—and by war's end he was a first lieutenant in the Signal Corps, serving in the Pacific.

Trent had grown up in New Brighton, Beaver County, and graduated from high school there. He studied pre-engineering at Wittenberg, and after the war, he earned a degree in chemical engineering at what was then Carnegie Tech, now Carnegie Mellon University. He worked for Koppers Company for forty-two years. He and his wife, Ruth, have lived in Ben Avon since 1959.

War had begun in Europe in 1939 with the German invasion of Poland, an attack that drew France and the British empire into the conflict. Those events three thousand miles away soon had an effect on Pittsburgh's Simkunas family, Viola Simkunas Stanny, ninety-seven, recalled in 2014. Her brother, Albert Casimir Simkunas, had joined the Royal Canadian Air Force in 1940. After the Japanese attack, Simkunas, who grew up in the city's Soho neighborhood, was reassigned to the U.S. Navy and eventually became a Marine Corps fighter pilot. Shot down and rescued at sea, Mr. Simkunas was awarded a Distinguished Flying Cross.

Viola Stanny, who was then single, and her mother, Agote, ran Vi's Bar on Forbes Avenue in Soho. "Everyone seemed to go a little haywire," she said of the days after the Japanese attack. Business boomed at taverns and private clubs, she said. Couples who had put off getting married decided to tie the knot. Long retired from the bar business, Stanny has lived for many years in Baldwin Borough, about nine miles south of Pittsburgh.

While December 7 was a memorable day in Miller's life, an event in the spring of 1943 stands out more clearly. That was when he (at age sixteen) and his father, Emery (then thirty-eight), both joined the U.S. Navy. William Miller's age was a concern. The recruiter checked first with the teenager's father and then with his own superiors. "The decision was that because I would be seventeen by the time I finished boot camp, it was OK for me to join up," William Miller recalled.

When the two Millers enlisted in the navy, they joined William's older brother, Elmer, who was already in the army. June 6, 1944, found Mr. Miller, still three weeks from his eighteenth birthday, serving as a signalman on a landing craft mechanized, or LCM. His vessel was ferrying American soldiers from troop ships onto French beaches on D-Day. "We made eleven trips [to Omaha Beach] in twenty-four hours," he recalled. On each journey,

their LCM could carry one tank or fifty men. He celebrated his eighteenth birthday on July 1, 1944, in France, transporting army rangers on a mission to destroy or capture German S-boats. The *Schnellboot* was the German equivalent of the U.S. Navy's P-T boat.

Discharged in May 1946, he returned home. He worked for many years as plant supervisor for St. Regis Paper at its facility in Pittsburgh's Strip District.

When Regina and the other survivors from the *Utah* reached the shore on nearby Ford Island during the Pearl Harbor attack, navy hospital nurses gave them dry clothes. He then reported for duty that day aboard the USS *Medusa*, a navy repair ship. Regina soon was reassigned to the USS *St. Louis*, a light cruiser undamaged during the Japanese attack. His ship, which participated in multiple campaigns in the Pacific war, was nicknamed the "Lucky Lou." The ship's luck didn't last. In July 1943, a Japanese torpedo "blew the bow off," he recalled. Regina's luck did. He came through the war without a scratch. He returned home in 1946 and went to work for the next thirty-six years at U.S. Steel's Edgar Thomson Works.

For many years, he did not talk about his wartime experiences. As the number of World War II veterans and Pearl Harbor survivors has declined, he has begun to open up. "I was shy," he said. "But I realized I had been lucky to come through without being wounded. And I had some stories to tell."

1942: Eight Brothers Go to War

Staff Sergeant Thomas P. Murphy saw his baby daughter, Aileen, once, his brother Joseph E. Murphy recalled. The Pittsburgh native was killed in action a few months later during the Battle of the Bulge. He was one of eight brothers from a North Side Pittsburgh family who served in the United States armed forces during World War II.

"He was a big, powerful guy who had played football," Joseph Murphy recalled in an interview he gave a few days before Veterans Day 2014. "The last time I saw him, we had a beer at Bishop's Cafe on Federal Street."

"Tom was one of the good guys," another brother, Edward Murphy, agreed. Thomas Murphy's daughter, now Aileen Tapp, is a Catholic school principal in Florida.

Joseph, ninety, of Verona, and Edward, eighty-six, of Butler, were the two surviving Murphy brothers in 2014. They and their sister Margaret "Peggy"

Joseph Murphy, one of eight brothers to serve in World War II, describes what happened to his siblings in the war and afterward. *Courtesy Bob Donaldson/*Pittsburgh Post-Gazette.

McCloskey, eighty-one, who lives in Beaver, grew up in a family of twelve children in which their parents emphasized patriotism.

When Joseph Murphy talked about his World War II service and that of his brothers, he had a visual aid to help jog his memory. His son-in-law, Blase Santoriello of Freeport, created a photo collage with pictures of all eight brothers in their service uniforms.

As Joseph Murphy pointed to the images of each of his brothers, he talked about how they had all grown up in Pittsburgh's Observatory Hill neighborhood during the worst years of the Great Depression. Despite those tough times, the Murphy children were encouraged to stay hopeful. "My mother instilled in us a great love for this country, where we all were able to make good lives," he said.

Their mother, Nora, and their oldest brother, Martin, came to Pittsburgh from County Kerry, Ireland, in 1912. Nora Murphy was coming to be reunited with her husband, Patrick, who had arrived in America one year earlier. According to family history, Nora and Martin originally had been booked on the *Titanic*, which sank on April 15, 1912, after it hit an iceberg. A last-minute change of plans saw mother and son leave Queenstown, now Cobh, Ireland, a few weeks later on the smaller, older *Coronia*. The decision to switch ships probably saved their lives, Nora's granddaughter Patti Cavanaugh said. She is Edward Murphy's daughter and lives in Butler.

"When I went to bed last night, I couldn't sleep," Joseph Murphy said of the evening before he was interviewed. "All of these memories floated up." While he talked about his brothers, his daughter Maryann recorded him telling stories with the camera in her tablet computer. "It was the Depression that molded us," he said. "Those were hard times. My brother John was very bright, but he had to quit school in the tenth grade."

John L. Murphy did very well for a high school dropout. He joined the army as a private in 1939 and retired in 1964 as a lieutenant colonel. He had been a soldier for only a few months when he was tapped as potential officer material, Joseph Murphy said.

Even before they began their military service, the five oldest Murphy boys had enlisted in President Franklin Roosevelt's Civilian Conservation Corps. Martin, Eugene, Thomas, John and Daniel were among the almost 3 million unemployed young men who took part in the public works program. Corps members, who were subject to quasi-military discipline, built hundreds of parks and planted billions of trees between 1933 and 1942 in return for room, board and small wages.

Brother Eugene was the only one of the family's nine sons not to have served in the military. He was employed as a defense worker with Westinghouse Electric Corporation and the company would not let him go, Joseph Murphy said. The family also included sisters Anna Marie, Kathleen and Margaret.

Irish-born Martin Murphy was thirty-eight and married when he was drafted into the army in 1943. He saw service in Europe through 1945.

Daniel M. Murphy was a marine who served during both World War II and the Korean War. He earned a Navy Cross for bravery during the battle of Chosin Reservoir in November and December 1950. As a result of his heroism, he was inducted into the Hall of Valor at Soldiers & Sailors Memorial Hall and Museum in Oakland.

Daniel Murphy looked like a marine, Joseph Murphy said. His duties included being a member of the honor guard for President Harry Truman. His photo is featured on a 1941 Marine Corps recruiting poster. One of the Murphy family's treasured keepsakes is a copy of the poster that shows color guard Daniel Murphy carrying the Marine Corps Flag.

Joseph, born in 1924, was drafted in 1943 after he finished high school. That was in time to get him sent to Luzon in the Philippines, where he was a driver with the 706th Tank Battalion. "Manila was called the Pearl of the Orient," he said. "But when I saw it, the entire city had been demolished."

It was in the Philippines that he had his closest call. "I was out on point," he recalled, doing a job that left him most exposed as his unit moved through hostile territory. "It was very dark, and I got lost in a rice paddy." Then he heard enemy soldiers talking nearby. "I crouched down as low as I could go," he said. "They kept going, and I got back to my outfit."

Before the war ended, three younger Murphy brothers also were in uniform. William Regis Murphy and James Vincent Murphy served in the navy in the Pacific Theater. Their youngest brother, Edward P. Murphy, joined the merchant marine at age sixteen. He then enlisted in the Marines Corps the following year.

While he was at sea as a teenage merchant mariner, Edward suffered an attack of appendicitis and needed an immediate operation. "Because he was so young, they had to call his mother to get permission to operate," his daughter Patti Cavanaugh said. "This was one of his favorite wartime stories."

Margaret McCloskey, Joseph's and Edward's surviving sister, was elementary school age while her brothers were away at war. "I remember when they came home on leave, my mother made sure that anything they wanted, they could have," she said. The boys' mother, Nora Murphy, was a loyal correspondent. "She wrote to one son or another every day," McCloskey said.

The Murphy family's tradition of military service continued in the next generation among Nora and Patrick's grandchildren. Those in uniform included marine corporal James Ganano, the son of Kathleen. He was killed in action in Vietnam in 1969. His picture has been placed in the center of the photo collage showing all his uncles in their World War II uniforms.

Joseph Murphy shut his eyes for a moment while he reflected on his military service and that of other family members. "In many ways, they were the worst years of our lives and also the best years," he said. "That's because we were young."

1944: The "Bulge," or When Hitler Gambled and Lost

Nick Diloreto remembered that it was so cold in Belgium during the Battle of the Bulge that the ground had frozen solid. "We couldn't dig foxholes," Diloreto, ninety, said. He and his buddies in the 131st Anti-Aircraft Artillery Battalion managed to stay warm at night, however, thanks to feather-filled

sleeping bags, which the soldiers tagged with a lighthearted nickname. "We'd just crawl into our fart sacks with all our clothes on," Diloreto said. A retired retail store manager, he lives in Scott. He and other "Bulge" veterans were interviewed in 2014.

First Division radio operator George Pietropola, ninety-five, had similar memories of the bitter cold in the Ardennes Forest in December 1944 and January 1945. "My hands and my feet were frostbitten," he recalled in a recent interview. A longtime resident of Penn Hills and Monroeville, he now lives with his son, George Jr., and daughter-in-law, Patti, in Cranberry.

Charles Frank, ninety-two, of Rochester was serving in the 94th Infantry in France when the Battle of the Bulge began on December 16 with a surprise German attack. His division initially had the task of keeping about sixty thousand enemy troops bottled up in the ports of Saint Nazaire and Lorient after the Allied sweep across France. Relieved of that duty, the men of the 94th were ordered to advance into Luxembourg and face the advancing Germans. "I ate Christmas dinner on the way to the front line," Frank recalled. "We were loaded into a freezing cold boxcar—forty guys—and that is how we moved to the front."

The Battle of the Bulge was the last great German counterattack on the Western Front. Military historians say it was undertaken with the hope of recapturing the Belgian port of Antwerp and forcing the Allies to accept a negotiated peace rather than demanding unconditional surrender. Fighting that began in mid-December continued through January 25. American losses—killed, captured, wounded and missing—totaled about 80,000, with the Wehrmacht losing as many as 100,000 soldiers.

While the Germans were able to push about fifty miles into Belgium—creating the bulge in the Allied lines that gave the battle its name—they were unable to capture the crossroads town of Bastogne. The siege of that Belgian city is probably the best-known engagement in the month-long battle.

American units, most notably the 101st Airborne, were surrounded by the enemy tanks and infantry starting December 20. When the German commander, Heinrich von Luettwitz, demanded surrender two days later, the U.S. commander, Anthony McAuliffe, responded with a single word: "Nuts."

Troops from General George Patton's Third Army broke through on December 26 and 27, ending the siege. George Kokiko, ninety-one, was part of General Patton's relief force as a soldier in the 328th Regiment of the 26th Infantry Division. A retired nonprofit executive, he lives in the McMurray section of Peters. Kokiko had been in frontline combat for

sixty-seven days following the Allied invasion of Normandy. His unit had been pulled back to Metz, France, to regroup and rest when the German push through Belgium began.

"Gen. Patton volunteered the Third Army to go up to the 'Bulge' and stop the enemy," Kokiko said. "They put us on a truck, dumped us out in Luxembourg and told us to go out until you meet the Germans." Their job was to protect the right flank of General Patton's army. He, too, has memories of intense cold and snow as they got closer to the enemy. Seventeen days of combat followed, as Allied troops began to push back the enemy. On January 6, 1945, he and his unit were facing German artillery fire at Wiltz, Luxembourg, a small town not far from Bastogne. Shrapnel struck him in the face. "It was what they called a million-dollar wound," he said. That meant that it was serious enough to get the victim out of combat for a while but not result in death or a disabling injury. In his case, his gums were damaged and he lost teeth. He was sent to the rear for surgery to remove the metal fragments.

As a boy, Kokiko had peddled newspapers from a street corner stand in his hometown of Uniontown. He recognized the army physician who operated on him as one of his daily customers back home. "After he pulled out the shrapnel, he sent a piece of the metal to my parents and told them that I was doing OK," Kokiko recalled.

His weeks of rest, recovery and rehabilitation included time in a hospital in England. It was late February when he rejoined his unit, which had pushed into the heartland of Hitler's Third Reich. "We walked across Germany, through Bavaria and into Austria and Czechoslovakia," he said.

When war ended in Europe in May 1945, he began training in German forests for the invasion of Japan. That country surrendered in September, shortly after the United States dropped atomic bombs on Hiroshima and Nagasaki. Kokiko earned both bachelor's and master's degrees with the help of the postwar GI Bill and worked for many years for social service and nonprofit agencies, retiring in the mid-1990s.

While Diloreto came through the Battle of the Bulge without a scratch, his family still faced tragedy. The Diloreto brothers grew up in Windber, Somerset County, and all four siblings saw service during World War II. Nick Diloreto hadn't known that his younger brother, Alfred, nineteen, had been serving nearby. "A chaplain came up to the captain's tent with a bottle of whiskey and asked for me and another buddy of mine," Diloreto said. "He asked us if we wanted a drink, and then gave us his blessing. Then he told us, 'I have bad news for you fellows—we've been

notified by the American Red Cross that both your brothers have been killed in combat.'"

Diloreto learned that Alfred had been only about a quarter mile away when he died. "I don't think our mother ever got over the loss of her son," he said. He and two other younger brothers, Anthony and Charles Henry, who still live in Windber, survived the war. Diloreto had his brother Alfred's Purple Heart medal framed. It hangs on the wall of his home in Scott.

While Mr. Frank came through the Battle of the Bulge unwounded, his number came up on February 27, 1945, as the Allies crossed the Saar River and attacked the Siegfried Line. "When I got shot up with a machine gun… it was like somebody hit me with a whip," he said. "I saw blood coming out of my hand." His fingers were mangled. He began a months-long treatment and recovery at hospitals in Luxembourg, France, England and, eventually, Indianapolis. After the war, he returned to Rochester, where he worked at a refinery for forty-three years. He started as a laborer and retired as an area supervisor. Keeping up the family tradition of military service, his grandson, David Frank, is a Marine Corps captain who has served several overseas tours of duty.

Thinking back to his own military service, Mr. Frank said he often didn't know enough to be scared. "I didn't think about surviving," he said. "I knew that an artillery shell already would have landed by the time you heard it and hit the ground."

1945: Inches from Death at the Roer River

George Pietropola faced the German army on the beaches at Normandy and in the snowy woods of Belgium. While conditions during the Battle of the Bulge were bad, Pietropola said his experiences during the Allied invasion of France had been worse.

When Pietropola waded ashore in Normandy on June 6, 1944, he found himself moving past many dead or wounded comrades. He was part of the third wave of U.S. soldiers to land on Omaha Beach. But likely the closest he came to sudden death was in February 1945 on the banks of the Roer River. The Roer, or Rur, flows through Belgium, Germany and the Netherlands. It served as a natural obstacle to the Allies as they invaded the Third Reich during the closing months of World War II. (The better-known Ruhr River is farther south.)

George Pietropola, a Pittsburgh native, came closest to death in the last months of World War II. *Courtesy Julia Rendleman/*Pittsburgh Post-Gazette.

"We could see the Germans on the other side," he recalled during a 2014 interview at his home in Cranberry Township, about twenty miles north of Pittsburgh. That meant that enemy soldiers could see him as well, and they could direct German mortar and artillery fire at his position. But the greater danger to Pietropola and the members of his squad was buried nearby. They had just scrambled out of a command car to set up a communications outpost. The area was heavily mined, he recalled, and after a while a soldier came along with mine-sweeping gear. "You're lucky to be alive," he told Pietropola, the unit's chief radio operator. "Your tire missed a teller mine by a couple of inches." One wheel of their command car, a hybrid vehicle that was half jeep and half truck, had been parked next to a German anti-tank mine. Deadly danger from mines, artillery shells and mortars was a constant presence for Pietropola and his comrades.

In May 1945, just after the war in Europe ended, Major General Raymond McClain presented then staff sergeant Pietropola with a Bronze Star for his heroism under fire from February 9 to February 24. His medal and a photograph of him receiving the military honor are framed and hang on the wall of his suite in Cranberry. A longtime resident of Penn Hills and Monroeville, he has lived since 2011 with his son, George Jr., and daughter-in-law, Patti.

Earlier in the war, his unit came under heavy German attack during what became known as the Battle of the Bulge. What did he remember seventy years later about the last large-scale German attack on the Western Front? He recalled a long, slow retreat through Belgium under artillery fire. He estimated it was at least a month before his unit was able to fight back to its original position and resume the Allied advance toward Germany.

Pietropola was born on December 2, 1919, in Pittsburgh's East Liberty neighborhood. He played football for Westinghouse High School until he dropped out in eleventh grade to start work at American Steel Foundries in Verona.

World War II began for the United States with the Japanese attack at Pearl Harbor on December 7, 1941. In March 1942, Pietropola was drafted. Although lacking a high school diploma, he scored high on Armed Forces intelligence tests. As a result, he was trained as a radio operator. His advanced schooling took him across the country to army bases in Missouri, Louisiana, California and Washington.

By 1944, he was in Great Britain, part of a vast Allied army preparing to invade France. On June 6, that day came. With a radio strapped to his back and armed with only a pistol, he waded ashore in a rainstorm. His job was to provide communications between units of the First Infantry Division.

The landing ship tank, or LST, that carried him and fellow soldiers toward the French shore left them in deep water. That meant they all had to wade, then run and crawl up the beach. Many dead and wounded already lay on the sand, he recalled. He was carrying limited first-aid supplies, including morphine for pain and sulfa powder to fight infection. He was able to share those with a few of the men on the beach. "I kept yelling for the medic, but there were none around," he said.

After the war ended in Europe on May 8, 1945, Pietropola was selected to be part of a unit sent to Berlin, captured by the Soviets just a few weeks earlier. He had picked up bottles of French cognac, and he found Russian soldiers to be eager buyers of the fiery brandy. He estimated that he had earned as much as $5,000 reselling the French liquor to Soviet troops. "But I lost it all on the boat coming home," he said. A dice game was his downfall.

Back in the United States, he met and married his wife, Victoria, in 1946. His mother and her mother played matchmakers, he recalled. They were married for sixty-five years until her death in 2011. In addition to their son George Jr., the couple had two other children: David, who lives in Slippery Rock, and Donna, who died in 2003.

After the war, he went to work for his father-in-law, plasterer Vincent Siciliano, learning the trade on the job. The family lived for many years near other Siciliano relatives on Pearl Road in Penn Hills. Pietropola has five grandchildren and seven great-grandchildren. He and his brother Tony, ninety-three, of Plum are the last survivors from what had been a family of nine children.

Thinking back about his experiences at Normandy, during the Battle of the Bulge and along the Roer River, Pietropola shook his head. "I was so close to death, and I don't know to this day how I came out of it," he said.

His son George Jr. said his father rarely talked about his wartime experience when he and his siblings were growing up. That situation changed in recent years. "But since my mother died, he talks about it all the time," he said. Halfway through his tenth decade, George Pietropola keeps busy. He goes most mornings to exercise at the Cranberry YMCA. He follows that with afternoon activities at the township senior center.

Following dinner and a nap, he enjoys watching sports, especially football. Favorite teams in addition to the Steelers include the New Orleans Saints, the San Francisco 49ers and the Seattle Seahawks, his son said. What do those teams have in common? All are near bases where he served during World War II.

2014: Sailors Reunite with "Angel's Coffin"

Navy veteran Mel Zimmermann had a two-word greeting for the shipmate he saw for the first time in almost seventy years. "Hey, Swabbie," Zimmermann, eighty-nine, called out to Jack Clifford, eighty-six, as the two met up at Soldiers & Sailors Memorial Hall and Museum in Oakland. The date was May 17, 2014.

What brought them together after so many years was the image of a beautiful woman. Zimmermann, a pharmacist's mate and an aspiring artist, painted the pin-up portrait of the buxom woman for the bridge of the USS *Sangay* in 1945. Clifford, who served on the same ship, rescued and cared for the artwork for six decades after the *Sangay* was taken out of service in 1946. He donated the piece in 2011 to Soldiers & Sailors, where it is on display as part of the military museum's "World War II in the Pacific" exhibit.

"How about paying me the storage fee for taking care of your painting?" Clifford joked after the two men shook hands and embraced in front of the picture. They were surrounded by more than a dozen relatives who cheered and waved small American flags.

Clifford lives in Middlesex, Butler County, and Zimmermann resides outside St. Louis. Their only contact when they served aboard the *Sangay*, a munitions ship, was when Zimmermann treated Clifford for broken fingers following an accident. The two men reconnected through the joint efforts of their daughters.

Clifford's daughter, Sharon Johnson, came across a black-and-white photo of the painting while she was looking online for additional information about her father's old ship. The image illustrated the Wikipedia entry describing the battle history of the *Sangay*. Johnson updated the online encyclopedia's entry with the information that her father had donated the picture, called "Angel's Coffin," to Allegheny County's military museum.

Zimmermann, urged to do so by his wife, Mary, had been writing an account of his World War II service. That document led his daughter, Diane Barron, to the same Wikipedia article about the *Sangay*, where she learned about the current location of her father's work.

The two men had talked regularly on the telephone for two years while they made plans to get together in Pittsburgh to see the painting. The date they picked turned out to be Zimmermann's eighty-ninth birthday. "Here's your birthday present," Clifford said, handing his friend a package on the day they met. Inside was a golf shirt with the name "USS Sangay" embroidered on it. Zimmermann in turn gave Clifford a cap decorated with the name of their ship.

World War II navy veterans Jack Clifford, *left*, and Mel Zimmermann had not seen each other in sixty-nine years when they got together in 2014 in Pittsburgh. Clifford rescued and preserved a painting that Zimmermann made for the bridge of the USS *Sangay*. Both men served on the ship. *Courtesy Lake Fong/*Pittsburgh Post-Gazette.

"We are honored to have you here," Michael Kraus, curator and staff historian at Soldiers & Sailors, told the men as family members looked on.

"So this is the painting I have heard so much about," Mary Zimmermann said as she viewed her husband's work for the first time. Zimmermann said he had been inspired by the pin-up girls whose images decorated the fuselages of airplanes.

His painting shows a naked red-haired woman with wings sitting atop a spiky black floating mine. The Soldiers & Sailors exhibit uses a heavy white rope, strategically placed, to make the picture suitable for viewing by school-age visitors. The *Sangay*, which was longer than a football field and had a crew of more than three hundred men, transported thousands of mines like the one shown in Zimmermann's painting.

As they answered questions from reporters and family members, the two men joked about their experiences. Their nicknames aboard ship had been "Cliff" and "Doc." Zimmermann would have been known as "the pill pusher," Clifford said. "We also were called some other names," Zimmermann said.

Who was the model for the angel in the painting? "It wasn't the guys on the ship," Zimmermann said. "They were pretty ugly."

The USS *Sangay* had seen service delivering munitions to front-line positions in the South Pacific at places including Tarawa, Peleliu, Iwo Jima and Okinawa.

"This is one of the highlights of my life," Zimmermann, blinking back tears, said of the 2014 reunion with his shipmate. A retired commercial artist, he ran his own firm near St. Louis. He and his wife have four children, twelve grandchildren and seven great-grandchildren. The Cliffords raised six children at their home in Middlesex. They have sixteen grandchildren and seven great-grandchildren.

Kraus said "pin-up girl" art like "Angel's Coffin" had been very popular during World War II, but much of it had been lost.

Clifford had been one of the last sailors to leave the *Sangay* when it docked in Orange, Texas, in 1946, headed for postwar decommissioning. He asked a shipyard worker what would happen to the "Angel's Coffin" picture, and he was told that it likely would be scrapped. He was permitted to remove the picture from the ship's bridge. The painting spent the next six decades mostly wrapped up at his home in Middlesex until he donated it to Soldiers & Sailors in 2011.

Uncivil War

1863: Principal Meets the "Gray Ghost"

Pittsburgh principal James B.D. Meeds had quite a story to tell his students at South Ward School when he returned from summer vacation in 1863. Meeds had found himself a prisoner of Confederate colonel John Singleton Mosby while on a mercy mission for the U.S. Christian Commission.

Mosby became known as the "Gray Ghost" for his ability to lead rebel raids on Union forces and then disappear into the general population. He seemed real enough, however, to Meeds. The school principal was part of a U.S. Christian Commission team delivering morale-boosting supplies to Federal forces stationed near Warrenton, Virginia. The U.S. Christian Commission was founded in 1861 by Protestant ministers and national officers of the YMCA. It raised money and then sent civilian volunteers to army camps and onto battlefields with wagon-loads of religious texts, stationery and personal-care products.

Meeds had been principal for many years at Pittsburgh's South Ward School and apparently was taking a break from his school duties to aid the Union cause. In an August 5 letter to Joseph Albree, the treasurer of the U.S. Christian Commission, he described leaving Washington, D.C., on the night of July 29. He and his three companions were headed for the general headquarters of the Army of the Potomac, about fifty miles southeast of the capital.

The Christian Commission team decided to travel with a number of other wagon-driving sutlers. Sutlers were civilian businessmen who sold food

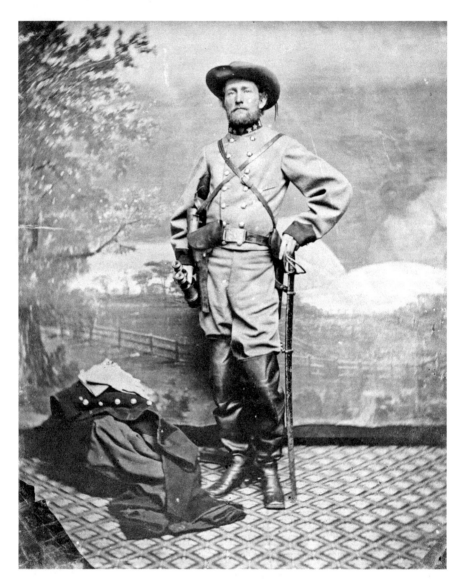

Confederate colonel John Singleton Mosby was nicknamed the "Gray Ghost." In 1863, Mosby and his cavalry captured a Pittsburgh school principal. *Courtesy Library of Congress.*

and supplies to the army. "[It] was thought safer to travel in company with them than to go alone," Meeds wrote. His letter to Albree was published on August 11, 1863, in the *Daily Pittsburgh Gazette.*

By the evening of July 30, their party was outside Fairfax, Virginia, and they decided to bed down near twenty-nine other wagon drivers. Meeds

estimated the value of the supply wagons and their goods at $100,000 (the equivalent of $1.9 million today), making the wagon train a tempting target for Southern raiders. Meeds was asleep in the wagon when he was "awakened by the noise of hurried voices." He went in search of a man he identified only as "Mr. Shaw," one of his traveling companions. "I was met by two or three men on horseback, whom I at first supposed to be sutlers."

"They inquired where I was going," Meeds wrote. "I told them, to call my friend Mr. Shaw. They said I could not go, that I was their prisoner." When Shaw turned up, the rebels robbed him of his watch, "worth $100, and $25 in money and his memorandum book, in which was his commission." That document would have explained the men's charitable mission and included approvals to travel through a war zone.

Meeds was no shrinking violet. "I requested to be taken to Major Mosby, the leader of the band, with whom I had an interview," he wrote. "I explained to him in as few words as I could the nature and object of the Christian Commission, and asked that we might be released." The Confederate officer was polite, saying he was familiar with the work of the commission, but he insisted that Meeds, Shaw and their driver remain with his forces. Mosby promised that "he would attend to our case at daylight."

As soon as the sutlers hitched up their wagons, the rebel raiders headed them northwest in the darkness toward Mosby's temporary headquarters at Aldie, Virginia, about twenty miles away. By 1:00 a.m., Meeds estimated that the captured wagon train was within a few miles of the town. Mosby's Rangers, however, were not the only troops in action that night. "Mosby's men were discovered by [Union] Lieut. Manning, who with 20 men, had been out skirmishing," Meeds wrote. "The band that surprised and captured us numbered about 40 men."

Despite being outnumbered two to one, the Union troopers attacked "spiritedly," but they soon were forced to withdraw. Pursued to the top of a nearby hill, they were besieged by rebel cavalrymen, giving "their demonic yells."

The tide turned when Union reinforcements arrived. "Col. Lowell, with a body of cavalry, who had been out all night in search of Mosby and his men, hearing the firing, hastened to the spot," Meeds wrote. When the rebels realized that they were now the underdogs, "they beat a hasty retreat and we were safe."

After getting a few hours of rest, Meeds and his companions traveled with armed escorts back into territory under Federal control. The next day, the Christian Commission's wagon joined a convoy with thirty-seven other

wagons. The supply train was escorted by six hundred soldiers to the Army of the Potomac's general headquarters.

"I am in the Station office, attending to things generally—supplying the soldiers with reading matter, writing paper, house-wives, &c," Meeds wrote. "Nothing seems to please the soldiers more than the little house-wife." No scandal here: a "house-wife," he explained, "is a little bag filled with needles, thread, buttons, &c."

"As many as twenty [soldiers] have been around the tent at once, begging for a little thread to mend their clothes," Meeds reported. "We have had to deny many, as we have but a short supply. If we had a thousand, they would soon go."

The Confederates left something else behind when they fled from the U.S. Cavalry. "One of the guerillas came to our wagon and handed us a sack, saying, Christian Commission, take care of that for me. We opened the bag and found it to contain 20 cans of peaches, 6 of oysters and 2 of catsup," Meeds wrote. "These we considered contraband and appropriated them to our own use."

Meeds went on to have a postwar career in finance as a founder and officer of Pittsburgh's Dollar Savings Bank. He and his family lived for many years in Oakmont in a house that still stands at 520 Seventh Street. He died in 1896 and is buried at Pittsburgh's Homewood Cemetery.

1863: CONFEDERATES CATCH A SOLDIER-SENATOR

Harry White may have been the man best qualified to evaluate conditions at Western Penitentiary in 1863. White was one of three state senators appointed that year to examine "the conditions of Institutions owned by the State or to which she makes appropriations," the *Pittsburgh Post* reported in its September 14 edition.

Those state-funded institutions included the prison in Allegheny City, now Pittsburgh's North Side, where more than one hundred Confederate officers were confined. They were members of Morgan's Raiders, Southern cavalrymen who had been captured in Ohio following a month of battles and skirmishes throughout the Midwest.

White, a lawyer from Indiana County, was not able to make the inspection trip to Allegheny County. He was himself a Confederate captive in Libby Prison in Richmond. He had been elected to the state Senate in 1862 while he was on active service as a major with the 67th Pennsylvania Volunteer

Infantry. President Abraham Lincoln granted him leave to attend to his legislative duties in January 1863, and he returned to the Union army several months later. Shortly thereafter, he was captured on June 15 in Virginia during the Second Battle of Winchester.

White's imprisonment left Senator George W. Stein, a Democrat, and Senator Charles McCandless, a Republican, to review conditions at the prison. They "made a careful examination, and manifested entire satisfaction with what they saw there," the *Post* reported. "The treatment of the Rebel Prisoners received their attention, and they evinced much astonishment in finding how very different from the actual facts were certain verbal and printed reports in regard to this matter, and reflecting on the civil and military officers having custody of these men." The *Post* was the city's dominant Democratic newspaper, and that second cryptic sentence in its story likely represented a dig at one of its Republican rivals, the *Pittsburgh Evening Chronicle*. Stories in the *Chronicle* had been critical of prison authorities for being too soft on the Confederates.

Partisan politics also intruded into negotiations over White's release from Southern captivity. Republicans, also known as Unionists, held a one-seat majority in the thirty-three-member state Senate in 1863. White was a Republican, and his absence produced a deadlock in the upper house, according to a January 1972 article in the *Western Pennsylvania Historical Magazine*. White had made several unsuccessful efforts to escape, one of which landed him in solitary confinement. In November 1863, he wrote out a letter of resignation and smuggled it out of prison, possibly in a Bible. While Democrats questioned the authenticity of the document, the receipt of White's note opened the way for a special election for his Indiana County seat. The Republican candidate, Dr. Thomas St. Clair, easily won, and with his swearing-in, the Senate was back in business.

After being transported to several other prisoner of war camps, White finally escaped Southern captivity in October 1864. Voters returned White to the state Senate. He later served several terms as a member of Congress and as a judge in Indiana County. White died in 1920.

1863: Making Ironclads on the Mon

Pittsburgh was known as a center for shipbuilding as early as 1811. Pittsburgh workers completed work that year on a steamboat called the *New Orleans* for entrepreneur Nicholas Roosevelt, an ancestor of President Theodore Roosevelt.

Fifty years later, businessmen and ship captains continued to look to the forks of the Ohio as a source for new vessels. "The reputation of Pittsburgh for rapidly building steamboats and the superior character of the workmanship put upon them has been so widely known that it is always the first point of thought of river men when they propose building a new boat," according to a story that appeared on April 9, 1863, in the *Daily Post*.

"[It] is generally conceded that a boat can be built here better and cheaper than at any other place above Cairo—and in a shorter time," the story said. The reference to Cairo was to the city at the southern tip of Illinois where the Ohio River enters the Mississippi.

A total of fifty-one new steamboats worth $1.5 million were registered at the U.S. Customs House in Pittsburgh in 1862, the *Post* reported. That number is equal to about $35 million in modern currency. The money spent on materials and employment of "many of our skilled artisans in several branches has…added greatly to our wealth and prosperity."

The pace of local shipbuilding picked up dramatically the following year as more civilian vessels were converted for use as troop transports and warships, the newspaper said. That increased demand meant that "every yard in the district is now pushed to its upmost capacity in constructing hulls, to which the upper works will be added here." Ten new boats had been registered as of April 1863, and another thirty-seven ships were in various stages of completion. In addition, Pittsburgh boatyards were under contract to construct four new ironclads for the U.S. Navy.

The firm of Mason & Snowden had one warship "well advanced," according to the paper, and a second "just begun." Operating on the south bank of the Monongahela River, near the Smithfield Street Bridge, Mason & Snowden had "the most perfect machinery for every operation required in constructing these boats." Tomlinson & Company had navy orders for two more ironclad gunboats. Its shipyard was about two miles upriver on the opposite side of the Monongahela, near the present-day Birmingham Bridge.

Mason & Snowden's ships, named *Manayunk* and *Umpqua*, were of similar size. Each was about 224 feet long, four times the length of the original ironclad *Monitor*. Both were armed with two cannons in their "cheese box" revolving turrets, according to a story by Louis Vaira that appeared in 1923 in volume six of the *Western Pennsylvania Historical Magazine*. That same article also described the two smaller monitor-class gunboats built by Tomlinson. They were named the *Marietta* and the *Sandusky*.

Monsignor A.A. Lambing, the president of the Western Pennsylvania Historical Society, described the construction of the gunboats in a story he

wrote for the January 15, 1900 edition of the *Bulletin of the American Iron & Steel Association*. A seminary student during the Civil War, he remembered observing all four ironclads being built, and he had been able to spend "considerable time examining [the *Marietta*] a short time before it was launched." The Civil War ended before final outfitting of the boats was completed, Father Lambing wrote. As a result, "all these boats were completed too late to take an active part in the great struggle."

1864: REBELS IN WESTERN PENITENTIARY

Spending eight months in Western Penitentiary persuaded 5 rebel officers to take an oath of allegiance to the U.S. government in March 1864. They were among 116 captured Confederate officers who were being transferred from the jail in what was then Allegheny City, now Pittsburgh's North Side, to a giant prisoner of war camp at the southern tip of Maryland.

The men had been imprisoned after their capture in July 1863 in Ohio. They were members of Morgan's Raiders, a Confederate force that sought to bring the Civil War north to communities in Ohio and Indiana. The stone prison where they were held stood on land now occupied by the National Aviary. The prisoners of war had been the subject of local curiosity, and their jailers had faced some criticism for what many saw as excessively lenient treatment. The *Daily Pittsburgh Gazette* had run several stories about the harsh conditions Union prisoners faced in Southern prison camps.

"A rumor of their departure spread over the cities, and a large crowd of people gathered around the Penitentiary to get a sight of the rebels as they passed," according to a story that appeared on March 19, 1864, in the *Gazette*. "The prisoners appeared to be in excellent condition, and made good appearance," the report said. "They looked neat and clean, and gave evidence of having been well provided for. They conducted themselves very quietly, and seemed pleased at regaining their liberty."

The ranks of the prisoners included a second lieutenant named Van J. Sellers. In 2014, postal historian Daniel Telep, of Sewickley Hills, a Pittsburgh suburb, assembled a collection of twenty-one letters that Sellers wrote from Western Penitentiary to a friend between August 1863 and March 1864. His letters to Nannie Lyne of Keene, Kentucky, provide a firsthand view of POW life at the jail.

Telep's collection also included envelopes for twenty of the letters. Those covers had markings indicating most of the correspondence had been read

Daniel Telep, a postal collector, holds a letter written by Confederate lieutenant Van J. Sellers when he was held prisoner in Western Penitentiary in 1864. *Courtesy Bob Donaldson/ Pittsburgh Post-Gazette.*

and passed by a military censor. Since Kentucky was a border state that did not join the Confederacy, Sellers's letters were sent via regular U.S. mail from Pittsburgh after they had been "examined."

One of the envelopes, however, has a Wheeling, West Virginia postmark. That letter, dated December 30, 1863, was sent "without examination by means of an underground passage by which I can send but not receive," Sellers wrote to Lyne. "Be careful when you write not to mention this letter."

In that same piece of correspondence, Sellers complained that at least one of his previous letters had not been delivered to his friend. "About that time two of the prisoners attempted to escape, and I suppose all letters mentioning it were considered contraband," he wrote. After that incident, prisoners were confined to their cells, were forbidden to have visitors and could no longer receive outside food items.

The ban on outside food lasted until March 13, 1864, just a few days before the prisoners learned that they were to be transferred to the POW camp at Lookout Point, Maryland. The last letter in Telep's collection was dated March 18, the day the prisoners left Pittsburgh by train. "At two o'clock this morning the Lord willing, I shall bid a tearful adieu to the ever to be well remembered walls of the Western Penitentiary," he wrote.

The *Gazette*'s March 19 story indicates that it was 2:00 p.m. before the Confederates were lined up, counted and then marched "under a strong guard of soldiers" to nearby railroad cars. "While they were at the [Pennsylvania Railroad] outer depot, a telegraphic dispatch was received by Capt. Wright from Washington, requesting him to detain five men who had expressed their willingness to take the oath of allegiance," the story said. The five were to be sent instead to Camp Chase in Columbus, Ohio. That army installation housed some prisoners of war, but it also served as a training camp for Union soldiers. The camp buildings all are long gone, but a Confederate cemetery where almost 2,700 rebels are buried is still there.

Captain Edward S. Wright, the Union officer who oversaw the Confederates while they were at Western Penitentiary, had a postwar association with the jail. He became the civilian warden in 1869.

The *Gazette*'s anonymous reporter wrote that a double rank of guards kept their eyes on the prisoners while they were being transferred to the railroad cars. Two other reports that appeared in the newspaper that week provided evidence that heavy security was a good idea. Escape remained a high priority for the POWs.

On March 20, another five hundred rebel prisoners had passed through the city on their way to the Point Lookout prison camp in southern Maryland. They had been guarded by soldiers from the Invalid Corps. That unit, also known as the Veteran Reserve Corps, was composed of partially disabled soldiers and veterans. "During their passage over the [Allegheny] mountains, seven of the prisoners succeeded in effecting their escape," according to a March 22 *Gazette* story.

Another report in that same day's edition noted that Captain Wright had received a "telegraphic dispatch" three days after the Confederates left Pittsburgh "announcing that the prisoners sent from the Western Penitentiary to Point Lookout had arrived at their destination." The trip, however, was not peaceful. "During the passage, one of the prisoners, named L.R. Payton… endeavored to escape." The fleeing man "was shot by one of the guard and instantly killed."

1864: "Thank You" for Knap's Battery

The "irregularity of the trains" meant that members of Knap's Battery were a day late arriving on furlough in Pittsburgh in 1864. Their hosts at a welcome-

home banquet in Allegheny City, however, made sure that they were not a dollar short in funding the delayed festivities for the combat veterans. "The table fairly groaned with the substantial and elegant dishes," the *Daily Pittsburgh Gazette* reported on January 18, 1864. (Allegheny City, now Pittsburgh's North Side, was a separate municipality during the Civil War.)

Two months later, the men from Battery E of the Pennsylvania Light Artillery were still talking about the warm reception they received during their leave. "Many incidents, which occurred in Allegheny and Pittsburgh, are rehearsed nightly to attentive listeners," a soldier-correspondent wrote in a letter to the editor published on March 24. "We are incapable of returning our thanks to the many friends at home in suitable language, but they may rest assured that we all feel grateful to them for the excessive kindness which was showered upon us from every quarter," the letter said. "[The] only manner in which we can repay them is to do our duty to our country, so that neither Allegheny nor Pittsburgh need…be ashamed of the record of Knap's Pennsylvania Battery." The letter was signed "R.A.H." The author might have been Corporal Richard Henry, whose first and last initials match.

Knap's Battery was named for its first commander, New York native Joseph M. Knap. It had been formed in 1861 with soldiers mostly recruited in Allegheny County by local residents Charles A. Atwell and James D. McGill. The new unit elected its first officers in Washington Hall on Rebecca Street in Allegheny City. Washington Hall was also the site of the banquet given for the members of the battery after many of its veterans reenlisted in 1864. By that time, its gun crews had seen action in multiple battles including Antietam, Chancellorsville and Gettysburg. The unit's service at Gettysburg is honored with two battlefield monuments.

When Knap left the unit to become superintendent of Pittsburgh's Fort Pitt Foundry in 1863, Atwell was promoted to captain. He was in command when the battery fought in Alabama and Tennessee. The January 18 *Gazette* story reported that he was one of seven members of the unit killed or mortally wounded during fighting at Wauhatchie, Tennessee, in late October 1863. Atwell, twenty-two, was buried at Allegheny Cemetery. McGill then became captain.

When soldiers from Knap's Battery returned to active duty, they were sent south, first by train and then by foot, to Bridgeport, Alabama, on the Tennessee River. Their comrades were glad to see them. "As we gazed on the familiar faces of our old companions…we felt that we were home again," the letter to the editor said. The "old companions" were more recent recruits to

the battery who did not qualify for the home furlough granted the veterans who had joined in 1861. R.A.H. wrote that the men had no complaints about the warm weather in Alabama, "which is quite in contrast to the weather at home." Camp entertainment included "some beautiful selections from the Ethiopian masters, by Jackson and his brother contraband, Henry, whose performances on the banjo and tambourine throw Ole Bull and his violin into the shade." Ole Bull was a Norwegian musician and a founder of a failed immigrant colony in Potter County.

Knap's Battery took part in the battle for Atlanta, and its soldiers marched with General William Tecumseh Sherman across Georgia to the sea. The artillery unit was disbanded on June 14, 1865.

1864: *POST* BLASTS LINCOLN'S SECOND RUN

James P. Barr, the editor of the *Daily Post*, was no fan of Abraham Lincoln. When the president-elect passed through Pittsburgh on Valentine's Day 1861, the closest thing to a compliment Barr could manage was to write that Lincoln was not "as ugly in the face as he has been represented."

When Lincoln was sworn into office in 1861, Barr's newspaper called his inaugural address "puerile." The new president's childish and silly speech would only "dash down the hopes and sadden the hearts of the people." The *Post* was the voice of the county's Democratic Party, and its coverage of the president became only harsher as the Civil War ground on. Its tone grew more vituperative as the presidential election of 1864 approached.

The newspaper called Lincoln a "heartless and unfeeling buffoon President." His "despicable tricksters" in Washington had promoted "mere poltroons and milksops" to top military posts, prolonging the conflict with the South. "The Administration at Washington has but a single purpose, and that is to secure its own re-election," the *Post* said on August 6, 1864. "It cares nothing for the lives and property of the people."

Barr and his newspaper flirted with treason that same day in a story quoting a New York newspaper editor named George Wilkes. Wilkes, a former Lincoln supporter, had called on the president to sacrifice his "personal ambition…and resign." At that point, Wilkes stepped well over the line. Lincoln "should remind himself that Caesar was ambitious," the editor wrote. His readers would have remembered that Julius Caesar's ambition led to his assassination.

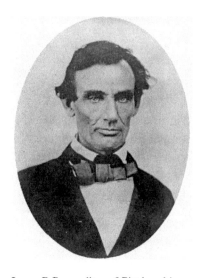

James P. Barr, editor of Pittsburgh's *Daily Post*, disliked the beardless Abraham Lincoln when he ran for president. In 1864, he urged his readers to deny Lincoln a second term. *Courtesy Library of Congress.*

Two days earlier, the *Post* published a mock-epic poem imagining a conversation between Lincoln and Columbia, a symbolic name for the United States.

Columbia, "careworn and pale," challenges "Lank Abraham" to defend his presidential record:

"Come, steward," she said, "now explain if you can! Why shan't I discharge you and try a new man?"

The Lincoln in "Abraham and Columbia" has limited his efforts to reading a joke book and humor magazine, "Consulting 'Joe Miller' and 'Vanity Fair.'" As did the real Lincoln, the Lincoln in the poem repeatedly quotes a proverb from a story about a Dutch teamster fording a river: "Taint safe to swap hosses when crossing a stream."

If that statement were true, Columbia asks, why did Lincoln replace so many of his generals in the midst of war? Those military men cast aside by Lincoln included two presidential rivals: John Fremont and George McClellan. Lincoln's reply in the poem is hypocritical and self-serving: "What's sass for the gander aint sass for the goose." In response, "Disgusted" Columbia gives up on Lincoln:

I have kept an old donkey for nearly four years,
Who brings me but scorn and disaster and tears!
I vow I will drive a respectable team,
Though forced to swap horses when crossing a stream.

"Corduroy," the pseudonym for the unknown author of "Abraham and Columbia," and the *Post's* Joseph Barr were in for disappointment when votes were counted in November 1864. Fremont, who initially agreed to be the candidate of the new Radical Democracy Party, withdrew before the election. McClellan, the Democratic Party's "peace candidate," was trounced by Lincoln, who ran at the top of the National Union Party ticket.

1864: THIS TIME, CHAMBERSBURG BURNED

Residents of Chambersburg had seen it happen twice before. In 1862 and again in 1863, rebel troops briefly occupied their town, burned railroad buildings and warehouses and commandeered military supplies, including horses. The secessionist forces then quickly withdrew, leaving most private property untouched.

Things would be different when Confederates commanded by General John McCausland captured the town on July 30, 1864. Community leaders were given an ultimatum: quickly come up with $100,000 in gold or $500,000 in U.S. currency, known as "greenbacks," or see Chambersburg burn. Those numbers are equal to about $1.5 million and $7.5 million in modern money. When the ransom wasn't paid promptly, McCausland ordered the town put to the torch. Chambersburg, the county seat of Franklin County, is about 160 miles east of Pittsburgh.

Three days later, on August 2, the *Daily Pittsburgh Gazette* published "a graphic and interesting description of the sacking of the town." The newspaper's eyewitnesses were four Chambersburg residents who "lost

Confederates raided Chambersburg three times during the Civil War. They did the most damage in July 1864, when they burned between 250 and 300 buildings, including the town hall. From *Harper's Pictorial History of the Civil War, Part Second. Courtesy Senator John Heinz History Center.*

everything they possessed, except what few articles of clothing they happened to have on when the pillagers appeared."

The *Gazette* speculated that the Confederates never believed that townspeople could raise that much money. "The rebels evidently did not expect to have their [ransom] demand complied with...and the work of arson and plunder began immediately," the story said. "In order to economize labor, and at the same time, make as sure work as possible, they fired every other dwelling. In private homes they generally lit up articles of furniture, piled them in the middle of the floor and ignited them...In a few minutes the beautiful, prosperous and peaceful town of Chambersburg was wrapped in flames," the story said. Most of the soldiers "turned a deaf ear to all entreaties," and some "gloried" in the destruction, "singing songs and shouting and dancing with demonic glee."

Not all the rebels were willing to follow their commander's orders, the eyewitnesses said. "They began to squabble among themselves, some refusing to apply the torch," the story noted. Other Confederates located and even began to work the pump on a Chambersburg fire engine, "trying to stay the flames" by spraying them with water. "Two rebel raiders were observed by one of our informants sitting on the sidewalk, weeping over the misery and distress which they beheld on every side."

While most of the town was destroyed, some residents managed to make their own side deals with the Confederates. "The son of the late Judge Kennedy paid $280 to an officer, conditioned for the safety of his own farm house and that of the old homestead of his father," the story said. "Both these buildings were saved." By contrast, a former state senator named George W. Brewer was told that if he agreed to give $500 to the raiders, his property would be spared. "He refused to pay and his house was destroyed," according to the newspaper.

Confederates had at least two reasons for torching the home of Alexander McClure, the editor of the local newspaper, the *Franklin Repository*: he was both an abolitionist and a leader of the state Republican Party. McClure was not home when the rebels arrived, but his wife, Matilda, was. She was not intimidated by the Confederate captain sent to destroy her house, according to the *Gazette* story. The officer identified himself as Frederick Smith, the son of William "Extra Billy" Smith, the governor of Virginia and, previously, the oldest general in the Confederate army. "It doesn't make any difference to me who you are," Matilda McClure told him. "If you are ordered to burn my house, the sooner you do it the better."

"Mrs. McClure endeavored to get away, but they detained her in the house, telling her they were ordered to burn the property in her presence," the story said. The soldiers began their work with axes, chopping up her parlor chairs for kindling. The rebels piled the wood in her bedroom, in front of "an elegant wardrobe in which were her finest dresses…and applied the torch."

"An unwilling witness to this act of vandalism," she had been allowed to "take a few items from her centre table as keepsakes, and these were all she saved." While the McClure mansion was reduced to a ruin, not all its contents were destroyed, according to the *Gazette*. "After the flames had begun to spread, several of the rebels got to work and carried out a larger number of the colonel's books, and, it is said, that nearly half his library was saved by them."

Confederate leaders apparently had done their homework before General McCausland led the raid into Pennsylvania and had up-to-date intelligence. "The rebels came prepared with a list [of targets] and seemed to be well posted [about] persons and localities," the eyewitnesses said.

At least some Confederates saw opportunities to enrich themselves. "Robberies were common on the highway and many persons were deprived of watches, jewelry and money by threats of personal violence," the *Gazette* reported. A man named Daniel R. Knight, "while carrying a child in his arms and helping some ladies out of town, was halted by a rebel who demanded his pocket book," the newspaper said. The request was backed up by the revolver the Confederate had placed under his victim's chin. "His pocket book was handed over, containing $30," the story said.

Chambersburg's Main Street was in ruins after the Confederates withdrew. From *Harper's Pictorial History of the Civil War, Part Second. Courtesy Senator John Heinz History Center.*

Chivalry, however, was not completely dead. Margaret McDowell, "mother of the late Captain [Samuel] McDowell, a distinguished cavalry officer killed at the battle of Marietta, had her house saved by making presents of preserves to the soldiers." Her son, an artillery officer, had died a little more than a month earlier in Georgia.

Chambersburg was destroyed in revenge for Union attacks directed by General David Hunter on military and civilian property in Virginia's Shenandoah Valley earlier in 1864. When the rebels left, shortly before midnight, they "took very little plunder with them, saying their mission was to destroy," according to the *Gazette*'s eyewitnesses.

"You can hurrah for Gen. Hunter now, and thank him for all this," one Confederate told a resident before he burned down her house. The newspaper report said that between 250 and 300 houses were burned, along with most downtown businesses, the county courthouse, town hall, a bank, six hotels, two private schools and two churches.

CRIME AND PUNISHMENT

1863: NUMBERS, NOT NAMES, AT WESTERN PEN

Inmates at Western Penitentiary, like the prisoners in Victor Hugo's *Les Miserables*, were never known by name, according to a May 4, 1863 story in the *Pittsburgh Post*. Each cell was numbered, "and they are known by the number on their cell."

The old state prison was built where the National Aviary now stands in Allegheny Commons. The building was a landmark in Allegheny City, now the North Side, until it was demolished in 1886. It gained additional notoriety in August 1863 when 118 captured Confederate cavalrymen were imprisoned there for about seven months.

Recidivism was a problem at Western Penitentiary, according to the *Post* story, with some inmates having "returned for the second and third time, and one man for the seventh time." The prison population in May 1863 was 230, including 8 women. "About twenty five [inmates] were colored," the story said. Those incarcerated ranged in age from sixteen to seventy.

The story gave no names for any of the prisoners, but one of the inmates was described as the half brother of Charlotte Jones. In 1858, Jones became the first woman executed in Allegheny County for her part in the double murder of her aunt and uncle. Her jailed half-brother most likely was Bill Jones, who was arrested and convicted in 1861 for the killing of his wife. "The youngest female prisoner is a girl rather prepossessing, who is in for the crime of infanticide," the *Post* reporter wrote. "She is very penitent, and

Prisoners at Western Penitentiary were known by numbers, not names, while they served their sentences in the nineteenth century. A plaque at the National Aviary on Pittsburgh's North Side marks the site of the prison. *Courtesy the* Pittsburgh Post-Gazette.

attributes her misfortune and crime to her seducer and her father. Her's is truly a case to be pitied." The writer was more suspicious of and had less sympathy for a woman convicted of trying to poison her husband and set fire to his barn. "As a matter of course she denies her crime," the story noted.

Western Penitentiary was designed to be up-to-date with nineteenth-century thinking about the goal of imprisonment. Jail time was imposed to give offenders opportunity to reflect on and repent for their crimes in isolation. "The prisoners are engaged in their cells and never see anyone, not even the minister who addresses them on the Sabbath," the story says. Idle hands being the devil's workshop, inmates were to keep themselves busy. "They are engaged in weaving, making shoes, trunks, &c, and each one has his task to do daily."

Those who didn't work, or didn't work hard enough, didn't eat. "If [the work] is not done, the number on his door is turned down...and he is deprived of his food until he makes up for the lost time." A stubborn prisoner would find himself "in a dungeon, and in almost all cases this suffices to bring him to his senses." Prisoners who exceeded their quotas

through "overwork" would have extra earnings they could spend to cover the cost of gas used to light their cells for evening reading. "A good library is connected with the institution, and they are allowed the use of books," the story says. Prisoners could correspond with the outside world once every three months. All letters—incoming and outgoing—would be reviewed by the warden, a former steamboat captain named John Birmingham.

Long before the Point State Park fountain became a Pittsburgh landmark, a similar, smaller attraction decorated the entrance to the penitentiary. The water in that fountain was always in motion, and "in the basin…are numbers of gold fish."

1863: No Conviction in Bully's Death

Judge Thomas Mellon put the fate of Bernard Lauth into the hands of an Allegheny County jury following several days of testimony about the gunshot death of John Kunzler. Presiding in the Court of Oyer and Terminer (nineteenth-century name for criminal courts in Pennsylvania), Judge Mellon charged the jury, describing the issues and law in the case, on November 20, 1863.

Lauth was twenty years old when he was accused of killing Kunzler, a man with a reputation for violence. The shooting took place on November 17, 1860, but Lauth fled the country afterward for England. He did not return until July 1863, according to testimony reported on November 20 in the *Daily Pittsburgh Gazette*. The journalist covering the trial frequently had to leave out letters in swear words as he reported courtroom statements.

Witness Jacob Hennigan said in a November 19 *Gazette* story that he had seen Lauth laying stone in front of a Pittsburgh business, Grierson's store, on the date of the incident. When Lauth caught sight of Kunzler coming toward him, he told Hennigan, "I must go: there comes Kunzler; he wants to fight me." He fled into the store. The witness told jurors that Kunzler asked for Lauth, saying, "If I find that d----d Dutch son of a b----, I'll kill him." A second witness, Nicholas Bachleitner, said he, too, "heard Kunzler's obscene menacing of Lauth's life."

The two men battled both in the store and outside on the street. In a gesture that seems to have been taken right out of a western movie, Kunzler momentarily stopped "to pull off his coat," before charging back into Grierson's.

Julius Parasky told jurors he was going to bed when he heard gunshots from what he believed was a pistol. "Just before the shots were fired he heard someone say: You son of a b----, I will kill you," according to the November 20 story. Parasky identified the speaker as Kunzler. "The witness stated he was a music teacher, and was a good judge of sound," the story said.

Defense and prosecution lawyers battled over testimony concerning Kunzler's character, but "after lengthy discussion the Court overruled the [prosecution's] objections." Policeman M.B. Hartzell testified that Kunzler was very ferocious and violent when under the influence of alcohol. Three other police officers and a prison guard agreed that the dead man's "reputation for peacefulness was bad." "Several witnesses were then called and testified to the physical superiority of Kunzler as compared with Lauth," the story said.

District Attorney John M. Kirkpatrick wasn't giving up. Later that day, he brought in several of his own witnesses to "rebut the allegations as to the disparity in size between Kunzler and Lauth."

It's not clear how long the jury deliberated after Judge Mellon sent them the case. In its November 23 story about a decision being reached, the *Gazette* described court procedure in detail. "In response to the interrogatory of the Clerk, the foreman…signified that they had agreed upon a verdict, and the indictment upon which the verdict was written was handed to the Court. It was then passed to the Clerk, and after it had been recorded, it was duly announced—'Not guilty.'"

"While the verdict was exceedingly gratifying to the defendant and his numerous friends, it was unquestionably a matter of surprise to many, who anticipated a conviction for manslaughter," the *Gazette* reporter wrote. "But the issue is settled and so it must remain."

1864: CHILDREN GET THE LEAD OUT
AT ALLEGHENY ARSENAL

As the Civil War entered its final months, some of the boys employed at Lawrenceville's Allegheny Arsenal found themselves at the center of a theft scandal. Three adults were charged with buying stolen lead, often in the form of bullet-shaped rifle balls pilfered by boys employed at the arsenal.

"The crime of receiving stolen goods is in itself bad enough," the *Daily Pittsburgh Gazette* said on December 9, 1864. "But encouraging children

Young employees smuggled expensive lead out of Allegheny Arsenal for resale to unscrupulous buyers during the last months of the Civil War. *Courtesy Senator John Heinz History Center.*

to steal, as these parties have been doing, is a most heinous offense and should be severely punished." At a December 8 hearing before Pittsburgh mayor James Lowry Jr., several boys admitted what they had done. Thomas Hughes, thirteen, and Michael Borden, fourteen, told the mayor that on several occasions, each filled his pocket with lead and walked out of the arsenal. They then found buyers who asked few or no questions about where the material came from. When one customer asked about the source of the metal, young William Donaldson "replied that they had been found at the [Allegheny] river."

Suggesting that there was little honor among thieves, Isaac Wood, "aged about seven years," testified that he had taken "nine bullets from the Arsenal once, but a boy named O'Connell took them from him." Margaret O'Connell, a widow who lived in Lawrenceville, was one of the adults charged in the case. The newspaper story doesn't indicate whether she was the mother of the O'Connell boy who took metal away from Isaac Wood. When police searched Mrs. O'Connell's house, they found a kettle filled with bullets and about one hundred pounds of lead that had been melted

into thirty-pound cakes. "The price paid by Mrs. O'Connell to the boys for balls was usually about 6 cents, so she could make a handsome profit," the newspaper said. The market price for lead was 15 to 16 cents a pound, according to that day's paper.

Testimony about pay at the arsenal—boys might earn as little as thirty cents a day—helped to explain their motivation. Mrs. O'Connell had paid Michael Borden fifty-six cents for seven pounds of lead, or about eight cents a pound. That amount was almost equal to two days' wages.

Mayor Lowry ruled that two of the buyers, Mrs. O'Connell and Michael Maloney, would face trial on a charge of receiving stolen goods. A third person, Albert Rusk, would face another hearing. The boys were freed with an agreement that they would return and testify against the adults.

1884: INSANITY CLAIM IN NUTT CASE

A lady's reputation was not to be trifled with in western Pennsylvania in 1884. A dispute in Uniontown over the honor of a sixteen-year-old girl left two men dead and a third on trial for his life in a Pittsburgh courtroom.

The murder trial of James Nutt had to be moved from Fayette to Allegheny County because of the passions raised by the complicated case. Nutt was accused of murdering a Uniontown lawyer named Nicholas L. Dukes in June 1883. Six months earlier, Dukes had killed Nutt's father, shooting him with a Colt revolver.

Dukes, thirty-one, had been courting the daughter of Captain Adam Clark Nutt, but he had declined to marry the girl. Captain Nutt confronted Dukes in Uniontown's Jennings House on Christmas Eve 1882 over statements he had made about Lizzie Nutt's lack of virtue. Both men were carrying guns. The dispute ended with Captain Nutt dead on the floor.

The story quickly developed a political dimension. Captain Nutt, a Civil War veteran, was cashier of the state treasury. As such, he was second in command to state treasurer Silas M. Bailey, a Republican. Dukes, a Democrat, had been elected to the state legislature a month before he shot Captain Nutt, but he was not sworn in because of the legal case against him. Dukes was tried on the murder charge in March 1883 in Fayette County, but he was found not guilty on self-defense grounds. All twelve men on the jury deciding the case were Democrats, newspapers noted.

Although advised to leave town, Dukes remained in Fayette County. On the evening of June 13, 1883, James Nutt, Lizzie's brother, fired five shots

at Dukes near one of the busiest intersections in Uniontown—the "round corner" at Pittsburgh and Main Streets. Struck by three bullets, Dukes died of his wounds.

Worried about finding an impartial jury in Fayette County, officials transferred Nutt's case to Allegheny County. Trial testimony filled page after page of the *Pittsburgh Commercial Gazette* in January 1884. On January 22, the newspaper ran full closing statements of both the defense and prosecution, as well as the judge's charge to the jury.

There was no disputing that Nutt had killed Dukes, so his formal defense was an insanity plea. Nutt's lead counsel, U.S. Senator Donald Voorhees of Indiana, took a different approach in his closing statement by attacking the character of Dukes and his dishonorable attentions toward Nutt's sister, Lizzie. Had he been in Captain Nutt's position, Voorhees "would have told him to take a double-barrelled shot-gun, fill each chamber with four inches of buckshot and shoot Dukes on sight," he told the jury. "So help me righteous God I would." After the jury was unable to reach a verdict that first night, Judge Edwin H. Stowe sent them home for the evening, telling them to restart their deliberations in the morning. The next day, the jurors returned a verdict of not guilty.

The editorial page of the *Commercial Gazette* and President Chester A. Arthur were in agreement that justice had been done. "It is as I had expected," President Arthur said in a story that appeared January 24 in the *Commercial Gazette*. "I did not think that they could get a jury in Pittsburgh, the home of Republicanism, that would convict Nutt for killing so infamous a man as Dukes."

"No higher crime can be committed against society than the wanton, insidious and deliberate destruction of female virtue," the *Commercial Gazette* thundered. "No jury will convict a man for defending his wife, mother or sister against the attacks of a moral monster."

"The Nutt jury has covered itself with glory," the newspaper said. "If it had not, its members would have found this a good town to make an expeditious escape from." The *Commercial Gazette* had a front-page chart showing the political makeup of the panel that acquitted Nutt: eleven Republicans and one independent.

Before he could return to the family mansion in Uniontown, James Nutt and his lawyers still had one task before them: to persuade Allegheny County judge Edwin H. Stowe that Nutt's insanity had been temporary. The county jail warden and two physicians, identified only by their last names, testified to the restoration of Nutt's mental soundness. "He is perfectly sane and has

been one of the best and quietest prisoners I have ever had," Warden Smith told the judge. "I think James Nutt is of sound mind and fully responsible at the present time," Dr. Beatty said. "He is in his normal condition mentally," Dr. Wiley agreed.

Judge Stowe found their testimony about Nutt's mental state persuasive. The newspaper story concluded, "After an imprisonment of 223 days, he was a free man."

1937: "EVOLVING" ROLE FOR TEACHER

Southwestern Pennsylvania had its own version of the "Scopes Monkey Trial" in 1937 when a Greene County schoolteacher was fired, in part, for teaching evolution. Laura Elms Morris, who had taught for eleven years in a one-room school, also was accused of assaulting her students with a baseball bat and a stove poker.

"Farmers and housewives of Kirby, [a] Greene county mountain hamlet…returned to fields and kitchens today while the Whiteley township school board waited to decide…whether to reinstate Mrs. Laura Elms Morris in her country 'school marm' job," *Post-Gazette* reporter James K. DeLaney wrote in a story that appeared on August 12, 1937. The five-member school board had dismissed the teacher that spring, but she used a new state teacher-tenure act to appeal her firing.

"On the stand for almost five hours in her own defense…Mrs. Morris lightly dismissed the evolution story as a 'joke,'" DeLaney wrote. She "refuted the cruelty charges with insistence that she was forced to strike one unruly pupil 'squarely on the seat.'"

School board attorney Jesse R. Scott asked Mrs. Morris whether "a certain pupil" showed her a magazine article on evolution. When she said he had, the lawyer asked her what she told him about Charles Darwin's theory that humans and apes had a common ancestor. "The audience, packed into the gas-lit schoolroom, stirred," the story said.

"I told him there was a theory of evolution worked out by a man named Darwin. I said some people support this theory and others reject it. I told him I didn't have time to explain it all to him, but that he could read about it in the Book of Knowledge." The Book of Knowledge was an encyclopedia. "The whole thing was passed off in the school as a joke," she told the school board. "That was all that was ever said in my schoolhouse about evolution."

DeLaney said Mrs. Morris had local supporters. "In the general store, as this story was written, there were several men outspoken in her behalf," he wrote on August 11. "They said the whole thing was a personal feud between one family and Mrs. Morris." Testimony ended "shortly after midnight when three boys and a girl testified she had taught them Darwin's theory."

On August 13, Mrs. Morris lost her appeal for reinstatement from the same board that had originally fired her. In their decision, the board members concentrated on the students' abuse claims and not on what she may have said about evolution. They "found that Mrs. Morris was guilty of cruelty inflicted on the Jones boys, Eugene and Jack, by striking them with an iron poker and a mushball bat." She also had failed to keep order in her schoolroom.

Her lawyer, J. Ernest Isherwood, appealed to Greene County Common Pleas Court. The county judge, C.W. Waychoff, excluded "testimony that Mrs. Morris taught her students that 'man is a monkey without a tail,'" according to a September 27 story that appeared in the *Connellsville Daily Courier*. Mrs. Morris's case ended with a compromise deal between her and the Whiteley school board. She handed in a written resignation, and the school board "granted her a clean bill of health and withdrew charges of incompetence," ending the county court proceedings. Mrs. Morris characterized the outcome as a complete vindication.

She continued to teach, retiring in 1959 from Greene County's Jefferson Morgan School District, according to her obituary in the *Waynesburg Republican*. She died on August 1, 1972, and was buried at Waynesburg's Green Mount Cemetery.

1962: Inmates Take Their Protest to the Top

While convicts protesting atop a water tower at Western Penitentiary provided free entertainment for many residents of Pittsburgh's Woods Run neighborhood, one young boy was outraged. Police created no-go zones on some of the streets around the prison after thirteen inmates climbed onto its water tower on June 25 and 26, 1962. The prisoners said they wanted to draw attention to what they claimed was harsh discipline.

The enhanced security separated David Chulack, nine, from a makeshift ball field on Doerr Street next to the state pen. "We've got bases painted in the street but the police won't let us go down there to play baseball," he

Prisoners at Western Penitentiary took their protests to the top in June 1962. Thirteen men climbed to the catwalk around a water tower in the prison yard that was more than one hundred feet above the ground. *Courtesy the* Pittsburgh Post-Gazette.

complained in a story that appeared on June 29. The situation, he told *Post-Gazette* reporter Alvin Rosensweet, was "horrible."

The top of the tower was about 135 feet above the prison yard. State Commissioner of Correction Arthur T. Presse and Warden James F. Maroney had "emphasized that they will not risk guards' lives by sending them up after the convicts," according to a June 30 *Post-Gazette* report. Officials opted to rely on summer heat and thirst to force down the convicts.

By the fifth day of the protest, daytime temperatures approached ninety degrees. The prisoners had been able to get some drinking water from the tower, but the supply had deteriorated. "To an old sign [painted on the tower] that said 'No water. Help?' the convicts added the word 'Mud,'" *P-G* reporter Vince Johnson wrote on June 30. "Apparently they wanted the public to know that the water tank contained nothing but sediment." Observers watching through binoculars reported that the inmates had been arguing among themselves. "Today the situation probably will be aggravated," Johnson wrote. "They have nine candy bars left and 10 men to eat them."

By Sunday, July 1, the end of a hot, dry weekend, only three men remained on the tower. "The convicts scrawled the word 'RAIN' on the tower in a gesture of supplication and circled the catwalk in a rhythmic tribal ritual," according to a July 2 story. The next day, two more men climbed down, leaving only Charles Cannen Miller, a murderer serving a life sentence, who "acted as if his perch were a throne," Johnson wrote on July 3. "Warden Maroney said that apparently Miller wants to become the tower-sitting champion of Western Penitentiary."

"Miller seemed both alert and active," Johnson wrote. "When the Gateway Clipper passed the penitentiary with a boatload of passengers, Miller responded to their yells by waving." The overnight forecast called for showers, which would both cut the heat and provide Miller with water "to enable him to ease his thirst." The rain turned out to be a mixed blessing at best. Early on the morning of July 3, "the rain and chill…were too much for Miller, who descended at 5:55 a.m." The protest was over.

Warden Maroney had said that he would not negotiate with inmates until the demonstration ended. Miller's surrender meant that "all 13 will be given a chance to air their grievances against conditions in the penitentiary," the warden promised in a *Post-Gazette* story on July 4.

Western Penitentiary opened in 1882 and served for many years as one of the state's maximum-security facilities. It closed in 2005 but reopened in 2007, operating as State Correctional Institution Pittsburgh. It houses minimum- to lower-medium-security inmates with drug and alcohol problems.

Chapter 7

ODD ANGLES IN EVERYDAY LIFE

1863: STREETCAR CUDDLING CRITICIZED

Maybe it was all that newfangled romantic Stephen Foster music they had been listening to, or maybe it was the result of waltzing too close together. Whatever the cause, the outcome was a public display of affection on a horse-drawn streetcar that left men staring and women biting their lips in embarrassment, according to a story in the *Daily Pittsburgh Gazette*.

"Hugging a pretty girl, at the proper time, and in a proper place, is no doubt very agreeable, and perhaps altogether allowable," a commentator huffed in the November 25, 1863 edition of the newspaper. "But it may be doubted whether a streetcar is the proper place to indulge in this luxury." The anonymous observer described in detail how scandalously "a very pretty young miss and a tolerably handsome gentleman" behaved during a trip across the Allegheny River from Pittsburgh to Allegheny City.

There was plenty of room in the streetcar when the couple stepped in and took their seats together in a corner. "Gradually the car filled up, but long before there was any necessity for his doing so, the gent shoved up a little closer still."

"As the car started off, the gent's arm...became restless and uneasy, and one might suppose it gave symptoms of rheumatism," the story said. "It finally got some relief, however, in being circled around the waist of the aforesaid miss...Now the hugging commenced in earnest, and was continued all the way over the bridge, up Federal Street to the Diamond, and how

much further is not exactly known." The Diamond was located at what is now Allegheny Center.

The dozen or more other riders on the streetcar "knew exactly 'what was the matter' but nobody 'let on'…There was some ogling and biting of lips by the ladies, and not a little staring and smirking by sedate and elderly gentlemen, but the hugging continued."

After several passengers left the car, the writer "naturally supposed that the 'lovers' would soon 'let go,' but they didn't…They did not even indulge in ordinary conversation, lest the 'magnetic current' might be interrupted, but numerous love glances passed between them…They seemed wholly unconscious of the mental criticisms that were being passed upon them, and evidently had no idea that their 'hugging match' would ever find its way into print," the story said.

The article concluded with a few lines of verse by the Scottish poet Robert Burns:

> *O would some power the giftie gie us*
> *To see ourselves as ithers see us;*
> *It would frae mony a blunder free us,*
> *And foolish notion.*

The lines are from his 1786 Scots dialect poem "To a Louse: On Seeing One On a Lady's Bonnet, at Church." Its theme is the danger of arrogant behavior in a world where personal appearance and social standing can be undermined by the smallest of things.

Those lines don't seem as apt as the words Burns wrote in a 1789 letter to his friend Alexander Cunningham: "I myself can affirm, both from bachelor and wedlock experience, that Love is the Alpha and the Omega of human enjoyment. All the pleasures, all the happiness of my humble Compeers, flow immediately and directly from this delicious source. It is that spark of celestial fire which lights up the wintry hut of Poverty, and makes the cheerless mansion, warm, comfortable and gay."

1883: GETTING RAILROAD CLOCKS TO AGREE

Now that the railroads serving Pittsburgh had agreed to follow a standard time, executive Robert Pitcairn confidently predicted that Pittsburgh City Council soon would follow suit. As it turned out, Pitcairn, the superintendent

of the Pennsylvania Railroad's Pittsburgh division, was much too optimistic. It took almost twenty years before the city made the change.

Before November 18, 1883, what time your train left Pittsburgh had depended on what line you were riding, the *Pittsburgh Commercial Gazette* reported on November 17, 1883. "Heretofore, the Pennsylvania Railroad has used Philadelphia time, the Baltimore & Ohio Baltimore time, the Pittsburgh, Cincinnati & St. Louis Columbus time," the *Gazette* said. All those times differed from locally determined city time. The result was a patchwork of times that made coordinating rail schedules next to impossible.

"The American people might be termed railroad people," Pitcairn told a reporter for the *Daily Post* on November 17. "We have adopted this standard suitable both to the railroad companies and the traveling public."

The plan to divide the country into four time zones would reduce but not end local confusion. Pittsburgh was right on the dividing line between the new Eastern and Central zones. When it was noon in Pittsburgh, according to local time, the watch carried by the conductor on a train arriving from Philadelphia or Harrisburg would show 12:20 p.m. Passengers from Cleveland or Chicago, following railroad time, would say it was 11:20 a.m. when they disembarked.

While the Pennsy's Pitcairn had hoped that the city would soon follow the lead of Philadelphia in adopting Eastern standard time, Pittsburgh officials would not be rushed. Ken Kobus wrote about the railroads' time conversion in the Winter 2005 edition of *Western Pennsylvania History* magazine. He found that train schedules continued to list city times for arrivals and departures until 1902. That left "the precise date unknown when the city finally switched" to standard time. And it wasn't until 1918 that Congress shifted the boundary between the Eastern and Central time zones away from Pittsburgh. The new dividing line was moved west to take in Ohio and most of Indiana.

The *Commercial Gazette* sent a reporter to Pittsburgh's Union Station, now the site of "the Pennsylvanian" apartment/office building, to see how the first day of standard time had gone. He found at least one puzzled employee. "Oh, go away, you make me tired," the unidentified railroad worker told the journalist in a story that appeared on November 19. He was seated "in front of the waiting room with his watch, a piece of paper and a pencil in hand," trying to work out train schedules. "If you can give me a pointer, I am willing to accept the favor," he told the reporter.

1937: SOAP BOX RACES DRAW FORTY THOUSAND

Walter Ritchey was the first boy to sign up for Pittsburgh's 1937 Soap Box Derby. He had been the runner-up in the 1936 competition, according to the August 2, 1937 edition of the *Pittsburgh Post-Gazette*. "All winter he saved parts and made designs, and when this year's derby was announced, he was the first to register," the story said.

More recent competitions have taken place in McKeesport, but they have been smaller-scale events. "Dozens of spectators lined the course, shouting tips at racers as they rolled past," the *Post-Gazette* reported after the 2012 race.

The 1937 event, held on an eight-hundred-foot-long portion of what is now Clairton Boulevard in Brentwood, was a much bigger draw. The derby that year was a two-day contest attracting 350 competitors from all over Allegheny County. The newspaper reported that "more than 15,000 fascinated spectators" came to cheer on the young drivers. They were piloting "a colorful collection of home-made speedwagons" during the preliminary heats on Friday, July 30. The *Post-Gazette* and twenty-eight of the region's Chevrolet dealers sponsored the event.

Brentwood was crowded all day long, the newspaper reported. "All morning…the roads leading into the suburban borough were filled with automobiles carrying the soapbox racers lashed to baggage trucks, hoods and fenders," the story said. "As tenderly as though the midget speedsters were expensive factory-made racers, the young pilots unloaded them and wheeled them up to the weighmaster's booth."

Race times in the '37 preliminary heats "were averaging well better than last year's," the story said. Walter Ritchey, the earliest registrant, appeared to be the boy to beat. The eleven-year-old driver, who lived in Pittsburgh's East End, had recorded the best time on the track during the initial races. Walter's time of 27.78 seconds, a record for the "Brentwood speedway," works out to about nineteen miles per hour over the eight-hundred-foot course. When the qualifiers from the first day's races returned for Saturday's finals there were as many as forty thousand people lining the course, according to the August 2 *Post-Gazette*.

While Walter was not able to match his preliminary time, his "white, bullet-shaped" vehicle was fast enough for him to become the Class B finalist. "The plucky, clean-cut youngster…got off to a bad start in the all-important final race, but put on a great burst of speed to overhaul Class A Winner Bob Severn," according to the paper.

The runner-up was gracious in defeat. "Walter Ritchey put up a fine race," the Severn lad was quoted telling the huge audience. "He deserved to win." Walter's prizes were substantial. In addition to earning the right to represent Pittsburgh in the national Soap Box Derby finals in Akron, he was given a gold medal, a trophy and, most impressively, "a shiny new 1937 Chevrolet." Depending on the model, the car would have been worth between $10,000 and $11,500 in modern currency.

Walter, however, suffered bad health and bad luck during the finals on August 15 in Ohio. The young driver "suffered a dizzy spell half way down the course and crashed into the side barricades," according to a *Post-Gazette* story the next day. The newspaper said that Pittsburgh's entrant had been feeling sick for two weeks, but on the day of the finals "he appeared at the track ready for action."

During the race, he relapsed. "He said later that his head began to swim and that his racing helmet at the same time slipped down over his eyes, blocking his vision." The only good news was that Walter was not injured in the track mishap, according to the paper.

1937: ELIZABETH PUPILS STRIKE FOR "PRINCIPAL"

Pickets surrounding all eight of Elizabeth Township's elementary schools may have been young, but they were feisty. About 400 pupils gathered at the entrance to the district's Wylie School in April 1937, protesting the dismissal of supervising principal Charles F. Montgomery. They were among 1,500 students from grades one through eight who had taken to the streets throughout the township.

At Wylie School, "They picketed the grounds about the two-story frame structure and refused entrance to anyone but teachers," according to the April 7, 1937 edition of the *Pittsburgh Post-Gazette*. "At the Boston school, the student strikers walked out of classes at lunchtime and refused to return. "Bearing placards which read, 'We Want Montgomery,' they milled about the entrance and paraded along the highway front the school." Eventually, police had to be called "to disperse the children, who thronged the streets in the path of motor traffic," the newspaper reported.

The young strikers may have taken their inspiration from labor actions elsewhere in the region and the country. The front pages of the *Post-Gazette* that month contained stories about a sit-down strike at a Hershey Chocolate

factory, pitched battles between rival AFL and CIO organizers at a vacuum cleaner factory in Cleveland, a contract settlement at Chrysler Corporation and Henry Ford's defiant vow never to recognize the United Automobile Workers as bargaining agent for his employees.

At the center of the Elizabeth Township students' strike was a sixty-nine-year-old silver-haired principal who had served as head of the schools for twenty years. With one year to go before mandatory retirement, Montgomery had been ousted following a four-to-three vote "at a secret meeting of the township school board," according to the newspaper. The fired principal told reporters that he had been the victim of "political sniping." "The youthful strikers stated their determination to remain away from classes until Montgomery is reinstated by the board," the newspaper said.

By the third day of the strike, both sides were digging in their heels. School director Robert McFaddon said that the board would not reconsider its decision to dump Montgomery and would call out the sheriff if the young pickets damaged school property. "The children continued their noisy but orderly demonstrations," the *Post-Gazette* reported on April 8. After a week, some students returned to classes, but 250 Wylie students went outside for recess and refused to return to their studies, according to a story the next day. A showdown was expected at an April 12 school board session "where protests and petitions from citizens and students are to be taken up."

Facing a hostile crowd of 150 parents and children at that meeting, the board first considered a delaying tactic. School director Albert Lacey proposed adjourning the session so board members could "go over the petitions to see if they are signed by registered voters," but his motion failed. When Lacey said the board had dismissed the veteran principal because members "wanted a younger man with high school supervision experience," he was booed. "It was then, after several minutes' debate, that the motion to reinstate Montgomery was made and passed," the *Post-Gazette* reported on April 14.

The returning principal was magnanimous. "Amid congratulations from parents and students, Montgomery said he held no ill feelings against any member of the school board and expressed thanks to the people of the township for their confidence in him."

1940: BLAWNOX TEEN MEETS HOLLYWOOD ROYALTY

As western Pennsylvania struggled to dig itself out from under a twenty-inch snowfall, *Post-Gazette* reporter Anna Jane Phillips was providing on-the-scene reports from sunny Hollywood on Pittsburgh's "Miss Seventeen." Betty Jean McCord, seventeen, a senior at Aspinwall High School, traveled by train to California in 1940. She had been selected "on the basis of personality and intelligence to represent Pittsburgh at the movieland premiere of Booth Tarkington's 'Seventeen,'" the newspaper reported on February 10. Tarkington was one of the country's best-known writers. His 1916 novel about first love already had been filmed as a silent movie and performed as a play when it was remade as a Hollywood feature.

The *Post-Gazette* had a photographer at the station in Pittsburgh on February 9 when McCord and Phillips prepared to leave. "Asked what she was particularly looking forward to in Hollywood…Betty Jean, caught up in the turbulent gayety of her send-off, her head swimming with great expectations, could only exclaim: 'Oh, everything!'" Over the next few days, Phillips wrote several stories describing McCord's experiences with film royalty. She was one of seventeen girls from seventeen cities around the country invited to Hollywood for the movie premiere. When she and the other young ladies arrived in Los Angeles, they were met by Jackie Cooper, the "suntanned and smiling" star of *Seventeen*.

McCord posed with Cooper and talked with actress Lillian Cornell, who was appearing that year with Jack Benny in a movie called *Buck Benny Rides Again*. "And ever so often she would race over to the Post-Gazette's reporter and whisper, 'Pinch me, I can't believe this is me,'" Phillips wrote on February 13.

Other highlights of McCord's trip included supper at Hollywood's Brown Derby restaurant. She and other Miss Seventeens were seated at a table next to actors Charles Boyer and Basil Rathbone. That was followed by dancing at a new nightclub called Ciro's, where she "chatted with Joan Crawford and Cesar Romero" and "discussed Pittsburgh weather with Spencer Tracy." "I just hate to waste time sleeping," she told Phillips in a story that appeared on February 14.

Seventeen premiered at the Paramount Theater in Los Angeles on Valentine's Day. McCord, her makeup done by the "same artists who make up the Paramount stars," attended the movie on the arm of Edward Arnold Jr., the nineteen-year-old son of character actor Edward

Arnold Sr. "Her gown of white moire was as lovely as any gown worn by any name-star there," Phillips wrote on February 15. "Yet it was made by her mother, Mrs. Thomas McCord of Blawnox." Her father was the supervising principal of Blawnox public schools. "Just one more day," McCord told Phillips on premiere night. "Just think, I'll always have this to remember—always."

Hollywood saved the best for the end. On her last day in Los Angeles, McCord "had an appointment with Jimmy Stewart, the Indiana (Pa.) lad who made good in Hollywood in a big way," the *Post-Gazette* reported on February 19, 1940. "He was the movie star Betty Jean was most anxious to meet, for she, too, was born in Indiana," Phillips wrote. "Jimmy posed with Betty for pictures" and "talked with her about their friends back home."

Stewart knew McCord's father from the time when her family lived in Indiana, her daughter, Nancy Carrey, related in a 2015 interview. Carrey said that her mother kept a scrapbook filled with newspaper articles and pictures from her visit to Hollywood as "Miss Seventeen."

During her return rail journey to Pittsburgh, McCord also had a chance to talk politics with Thomas Dewey. Dewey, Manhattan's district attorney, was seeking the 1940 Republican nomination for president. "Mr. Dewey said women are taking more part in politics than ever," McCord said in the story. She arrived home with a "well-filled autograph book" and "dozens of other souvenirs of her Hollywood trip," Phillips reported.

While she often reminisced about her trip to California, McCord went on to have a full and exciting life, her daughter said. After graduating from Aspinwall High School, she earned degrees from Slippery Rock and Grove City colleges and taught physical education on the elementary, high school and college levels. In 1946, she married Marine Corps pilot Herbert P. Mosca Jr., whose military career took them and their three children to many cities, including London and Washington, D.C. During her husband's second career with Grumman Aerospace, the couple lived in Tokyo, Hong Kong and Singapore.

The former Miss McCord briefly returned to teaching when her husband was stationed in North Carolina. The couple lived for many years in Columbus, North Carolina. Herbert Mosca died in 2004. Betty Jean McCord Mosca was ninety-one when she died on June 19, 2014, at a hospice in Landrum, South Carolina.

1956: BIG TOP FOLDS UP TENT HERE

First Ringling Brothers had lost Emmett Kelly, its sad-faced star clown, during a labor dispute. Then, following a final performance at Heidelberg Raceway in Scott Township, "The Greatest Show on Earth" lost its tents. "A great American institution—the circus under the canvas tent—passed away early today into history and folklore," *Post-Gazette* reporter Alvin Rosensweet wrote on July 17, 1956. Halfway through a summer season marked by terrible weather, transportation breakdowns and union woes, John Ringling North, board chairman, pronounced the "death sentence" for outdoor performances of the Ringling Brothers and Barnum & Bailey Circus.

"The tented circus as it now exists is in my opinion a thing of the past," North said in a statement that appeared in the July 16 edition of the *Pittsburgh Press*. The circus would close immediately and move the following spring into what he called "mechanically controlled" exhibition spaces. He was referring to indoor arenas like Madison Square Garden in New York City. North's surprise decision left almost eight hundred workers without jobs. Their severance was eight days' pay and transportation back to the circus's winter home in Sarasota, Florida.

It was during the circus's opening performances in New York in April that it lost the comedic talents of Kelly, who performed as "Weary Willie." Kelly had declined to cross a picket line, leaving the show without one of its best-known stars, Rosensweet wrote.

The last performance under canvas in Scott Township, about eight miles southwest of Pittsburgh, brought back *Post-Gazette* reporter William Rimmel's boyhood memories of growing up in Allegheny City, now Pittsburgh's North Side. Rimmel, who was born in 1897, wrote of "slipping out of the house long before dawn to meet the Barnum and Bailey Circus…And then for the next eight hours along with half a dozen other boys I carried gallons of water for the elephants." In return, he and his buddies were "permitted to sit among the throng inside the big top."

His story, also appearing on July 17, described meeting a personal hero. "Another boyhood thrill was the time my grandfather, an old circus man, took me behind the scenes of the Buffalo Bill Wild West Show to show me the one and only Buffalo Bill," he wrote. "The old scout shook my hand…I remember the trouble my mother had getting me to wash the hand that shook the hand of the great Indian scout that day."

The transportation and labor problems that had followed the traveling show in 1956 did not let up. A railroad car's breakdown delayed the afternoon

Traveling circuses used giant tents both for performances and for meal service, as is seen in this *Pittsburgh Press* photo from June 4, 1939. Then, in 1956, Ringling Brothers announced an end to its tented shows with a final performance under canvas in Scott Township, southwest of Pittsburgh. *Courtesy the* Pittsburgh Post-Gazette.

show by four hours. Protesters, part of an effort to organize drivers and performers, set up their picket lines outside the circus tent as they had in other cities.

Rosensweet wrote that the late-starting evening performance drew a capacity crowd of ten thousand to the Heidelberg Raceway. The last show was "a sad and a shabby end, hardly deserved by an institution of tinseled glory and laughs," he wrote. "But true to the tradition of the circus symbolized by Pagliacci, the clown, they gave a brilliant performance for their last audience, even though despair and grief dimmed eyes with tears." The raceway itself did not last too much longer. It closed in 1973 and was replaced by a shopping plaza.

Veteran *Post-Gazette* cartoonist Cy Hungerford also took note of the final show under canvas. His June 17 editorial cartoon, labeled "An Old Boyhood Friend Passes On," showed a tearful Uncle Sam mourning in front of a tombstone as "The Big Top" floats away on a cloud.

2010: A Barcousky Family Mystery

A few years ago I tried without success to talk my then fifteen-year-old son Peter into filling out the 2010 census with me as a father-son project. Seventy-two years later, if he stayed healthy and was lucky, he would be able to see the information that we wrote on that form at our home in Ben Avon, northwest of Pittsburgh. I explained that our replies might help our descendants answer questions about our family. He was not persuaded. "Long day, Dad," he explained, yawning, and excusing himself.

The 2010 form collected only the most basic demographic information: our addresses, ages and self-described racial identification. It also asked about our relationships to one another and, finally, whether we own outright, have a mortgage or rent the place we call home. When the data from this year's count is released to the public on April 1, 2082, amateur genealogists won't learn much about the Barcousky family.

Even the most pedestrian information from old census forms, however, still can produce some surprises. For me, the 1920 census offered some basic genealogical information about the Barcousky family. Overall, however, it raised more questions than it answered and suggested a mystery that never may be solved.

Mine is a family in which folks often marry and bear children later in life. My grandfather on my mother's side was born in 1863 somewhere in Russian-controlled Lithuania. There may well have been people in his village who remembered when Napoleon's armies invaded in 1812. Grandfather John, or Jonas, was forty-four when my mother was born in 1907. My paternal grandfather was a youngster of thirty-seven when his son, my father, was born earlier that same year. My mother was forty-two and my father forty-three when I was born in 1950. I was forty-four when our second child, Peter, was born.

One advantage of being an older parent is you realize how fast even the most vexing periods of child-rearing will pass. One disadvantage is that you worry about seeing your children grow up. Indeed, my mother lost her father when she was eleven. He died during the flu epidemic of 1918. It was a particularly virulent strain. The so-called Spanish influenza eventually killed more people than World War I by the time it had run its course. He and my grandmother, Victoria, who died in 1946, rest together at Our Lady of Lourdes Cemetery, just outside Shenandoah in Schuylkill County.

The family story, repeated many times when I was growing up, was that the flu also killed my paternal grandfather, Petras, or Peter, in that same

deadly year. From the beginning, however, there was some mystery about his passing.

The hills above Shenandoah and nearby Mahanoy City are dotted with small weed- and brush-covered cemeteries. Most were organized by now-closed churches, defunct fraternal organizations or burial associations no longer able to care for the graves. During the 1950s and 1960s, on what was called "Decoration Day" (an older name for Memorial Day), my parents and I would travel from the Lehigh Valley northwest to Schuylkill County to say a prayer and put flowers on family graves.

There were few mentions of my grandfather during those visits. As we made our Decoration Day

"Flu victim" Peter Barcousky, believed to have died in the flu epidemic of 1918, was found via census records to still be alive two years later. *Family photo.*

pilgrimage, my father, also named Peter, might gesture toward one of the abandoned graveyards and say that he knew that his dad had been buried in one of them, but he did not recall where. Years after my father's death in 1983, I talked with his slightly younger cousin, Joseph Balcius, who said that he remembered my grandfather's funeral and burial. It had been a very cold winter day, he said, and the gravediggers had struggled to open the frozen ground. He apologized and said that he had been very young—well under ten years of age—and didn't remember many details.

My grandmother Roze, or Rose, had remarried after her first husband's death, and she outlived her second, younger husband, as well. When she died in 1958, she was buried a few hundred yards from the grave of her second husband, Michael Kurzinsky. For at least a decade afterward, until I left for college, those Decoration Day visits included stops at my grandmother's and Michael Kurzinsky's graves.

Long-accepted family chronology was thrown into confusion a few years ago when I came across the 1920 census records for Shoemakers Patch. That was the name of the cluster of houses outside Mahanoy City where my father grew up. The enumerator who visited his house found that on

January 29, 1920, my father, his age given as thirteen; his mother, forty-five; his mother's cousin, Joseph Reckus, twenty-two; and his father Peter, fifty, all were residing there—two years after my grandfather was supposed to have been one of the millions of flu victims. Why the confusion in dates? And why did neither my grandmother nor my father ever pursue any efforts to find and mark my grandfather's grave?

The search would have been easier fifty years ago when those Schuylkill County cemeteries were much less overgrown than they are now. My father always seemed to recall and refer to his father with affection and sadness at his early passing. My grandmother died long before it would have occurred to me to ask her about her first husband. Was there some split between my grandparents that was so traumatic that it was never talked about? Had my grandfather left the Catholic Church, and for that reason, was he not buried in consecrated ground? Or were my father's and grandmother's recollections simply imperfect?

My grandmother became a widow sometime after 1920, and she had little family and no government benefits to help her. Did the demands of keeping food on the table and clothes on my father's back leave no time for remembering the past? I'm left with many questions and few answers. The only real evidence about the circumstances of my grandfather's death comes from those puzzling responses on that census form. There is no one in the family left to ask about the contradictions.

BIBLIOGRAPHY AND FURTHER READING

Andrews, J. Cutler. *Pittsburgh's Post-Gazette: The First Newspaper West of the Alleghenies*. Boston: Chapman & Grimes, 1936.

Baldwin, Leland D. *Pittsburgh: The Story of a City*. Pittsburgh, PA: University of Pittsburgh Press, 1970.

Barcousky, Len. *Civil War Pittsburgh: Forge of the Union*. Charleston, SC: The History Press, 2013.

———. *Remembering Pittsburgh: An "Eyewitness" History of the Steel City*. Charleston, SC: The History Press, 2010.

Donald, David Herbert. *Lincoln*. New York: Touchstone, 1995.

Guernsey, Alfred H., and Henry M. Alden. *Harper's Pictorial History of the Civil War, Part First*. Chicago: McDonald Bros., 1866.

———. *Harper's Pictorial History of the Civil War, Part Second*. Chicago: McDonald Bros., 1868.

Oates, Stephen B. *With Malice Toward None: The Life of Abraham Lincoln*. New York: Harper Perennial, 2011.

Thomas, Clarke M. *Front-Page Pittsburgh: Two Hundred Years of the Post-Gazette*. Pittsburgh, PA: University of Pittsburgh Press, 2005.

Index

About the Author

Len Barcousky in the *Post-Gazette* press room. *Family photo.*

A veteran journalist, Len Barcousky has worked for newspapers in New York and Pennsylvania. He is a graduate of Penn State, where he earned a bachelor's degree in English, and of Columbia University, where he received a master of business administration degree. Until his retirement in 2015, he had been a longtime editor and reporter at the *Pittsburgh Post-Gazette*, the oldest newspaper west of the Allegheny Mountains. He and his wife, Barbara, live in Ben Avon, Pennsylvania.

CPSIA information can be obtained
at www.ICGtesting.com
Printed in the USA
BVHW041519091218
535174BV00004B/21/P